5 STEP

QUANTUM
LIFE

5 STEPS TO A
QUANTUM LIFE

How to Use the Astounding Secrets of
Quantum Physics to Create the Life You Want

NATALIE REID

WINGED HORSE PUBLISHING

Library of Congress Control Number: 2007927029

Copyright © 2007 by Natalie Reid
All rights reserved

ISBN-13:978-0-9792110-0-3

Published by Winged Horse Publishing
www.wingedhorsepublishing.com

No part of this book may be reproduced or transmitted in any form or by any means, electronic or mechanical, including photocopying, recording, or by any information retrieval systems or by translation into any language, without written permission from the publisher.

For information on foreign or translation rights, please contact:
Nigel J. Yorwerth, President, Yorwerth Associates,
410 Fieldstone Drive, Bozeman, MT 59715
Email: nigel@PublishingCoaches.com

Cover design: James Bennett Design
Interior design and production: Rachel C. Jones & Sara L. Russell
Diagrams: Kris Strong

Printed in the United States of America
10 9 8 7 6 5 4 3 2

Note: The information contained in this book is not intended as a substitute for consulting with a licensed health practitioner. In no case should any of the statements in this book contribute to the delay or omission of appropriate medical treatment. Winged Horse Publishing and the author are not responsible for any adverse effects or consequences resulting directly or indirectly from the use of any of the suggestions discussed in this book.

CONTENTS

CONTENTS

To my dear friend L.,
with gratitude and love

ACKNOWLEDGMENTS

Thank you to my friend Laura Baxter, who spent countless hours discussing quantum ideas over coffee, laughing with me as we searched the poorly lit shelves of the local bookstore I used as my library, offering her enthusiastic encouragement on the writing of this book, giving me feedback when I read passages to her over the phone, and then carefully editing my work. Always her comments were smart, thoughtful, meaningful and exceptionally valuable.

Thank you to my friend and "official photographer" Kris Strong Clark for her wholehearted support of me and this book, for taking dozens of photos of me while we worked to create just the right ones, laughing with me while she taught me the technical details needed to design my web site, for providing the diagrams in this book and for using the book's ideas to generate her own

wonderful successes. Her enthusiasm is contagious and appreciated.

Thank you to my publishing consultant and foreign rights agent, Nigel Yorwerth, of PublishingCoaches.com and his partner, Patricia Spadaro, for their incredibly useful advice and guidance on the presentation and publishing of my book.

Many thanks also to Carlita for friendship and support.

INTRODUCTION

Like others before me, when I first learned how to use mind-body exercises, I was delighted to find that they worked. Using a variety of techniques, I was successful at creating jobs, better financial circumstances and improved relationships. As far as I knew, there was some law that made the techniques effective, but I had no idea what that law was.

More recently I studied quantum physics and was surprised to discover that this science, with its cold, hard, unalterable facts, explains why using personal, feeling-based mind-body techniques actually works.

It became immediately apparent that this knowledge—that quantum physics can account for the validity of nonphysical techniques—was not clearly recognized anywhere, at least not anywhere I could find. Certainly it's not discussed in the scientific community or by the

population at large; it is simply not common knowledge. While ideas about the quantum are offered in the spiritual/metaphysical community, the information has not been directly connected to mind-body exercises, nor has it been presented the way it is here. Since discoveries in the quantum were made nearly one hundred years ago and theories about the nonphysical aspects of life have been around for many centuries, it seemed remarkable to me that no one had married them together in this way and that the information was not already in the mainstream of society.

~

5 Steps to a Quantum Life introduces you to a realm of science that reveals a new picture of how the world works. By its own example, quantum physics demonstrates that we are far more influential in our lives than is commonly known. To show you the connection between quantum physics and the emerging vision of the world, I have put together the understanding I have gained over thirty years of study in the areas of psychology, meditation, stress relaxation and behavioral techniques with the scientific facts of

quantum physics. Integrating what I have learned about the intangible aspects of life—those that concern thoughts and feelings—with scientific facts, I developed the practical, five-step process presented here.

You can use this method to change anything in your life, whether it concerns a relationship or work problem, money, health, a new house, a car or a new profession you want. It will work best if, as you follow the steps as they are presented, you remain mindful of what transpires in your life. This is a powerful process that will succeed, and it works just as well for a new car as it does for improving your health. You can use the steps and techniques to create anything you want and to change your life.

I have seen this process work many times for many people, men and women just like you who wanted their lives to be different. I have watched these people receive wonderful gifts, meaningful relationships, new cars, jobs, money and restored health by using this method. Many of their stories are included in this book, so you will get to meet some of these people.

The five-step process is a practical course of action and it is not difficult to accomplish. You already have all

the tools you need, since they are your own thoughts and feelings. The process can take as long or as short a time as you need.

Do not worry if you don't understand every aspect of the science I present in the following chapters. This process will work for you whether the scientific explanations make sense or not. If the particular details of quantum physics seem technical beyond your grasp, just let those parts of the book wash over you. It is not important to figure out every point. The information about physics is presented here to help you make changes in your life, so if the scientific parts are confusing, do not let that get in your way. You absolutely do not need to understand anything about quantum physics to create a wonderful, joyful life.

Above all, follow the steps with your head and your heart and make the five steps as enjoyable as you can. Like anything in life, you will get out of it what you put into it. Holding the vision of what you want, make each of the steps meaningful and fruitful.

My wish for you is that you take hold of this process and own it, that you use it to make your life—and the

lives of those you love—richer, more successful and joyful, filled with meaning and adventure.

Chapter One

YOU CREATE
YOUR OWN REALITY

You create your own reality." Maybe you've heard that expression. What does it mean, exactly? It has an empowering ring of truth to it, but it's just an expression. It can't be true literally, can it?

A therapist will tell you that creating your reality means that when something happens, you create how it will influence you by the attitude you have about it. So, with your own interpretation, you create whether the driver abruptly cutting in front of you on the highway is hostile or merely careless, and you react accordingly. In a way, that is creating your reality. But you didn't create the guy's cutting you off. Or did you?

1

What if you knew what some scientists have known for nearly one hundred years? You do create your reality. Literally. You create all of it, even the other drivers on the road.

How would your life be different if you knew you had the power to make it the way you want it to be?

The good news is that the power is yours, and it all starts with accepting ownership.

STEP ONE: TAKE RESPONSIBILITY

If you are not responsible for something, you cannot change it, so taking responsibility is the first step and the foundation for the next four steps. In many ways, therefore, it is not only the place to start but also the most important of all the steps. Taking responsibility is vital, essential, crucial, and none of the other steps will work without this first one.

What does it mean to take responsibility? How do you do it?

Here's an example. You wouldn't dream of painting

your neighbor's junky-looking old car, the clunker with the rust spots, the one he insists on storing on cement blocks in the driveway adjacent to your beautiful lawn. Even if you detest looking at it, you wouldn't touch it because the car does not belong to you, and painting it would constitute vandalism.

Since it's not yours, you can't get rid of his piece of junk car either. In this example, however, you do own your home, and what you can do is plant a row of flowering shrubs along the property line, providing a wall of pretty greenery that completely hides the neighbor's driveway from your view.

Although it seems simple, the idea of honestly taking responsibility for what happens in their lives can stop people dead in their tracks. "I'm not responsible for this problem," they will say. "It's happening to me. I'm the victim here! Don't point your finger at me!" Taking the role of victim will not work for you. From a victim stance, you will not be able to change your life at all. You will have to decide to look at your situation from another point of view. As the saying goes, "There are no victims, only volunteers."

Many mistakenly believe that if they take responsibility for a situation, it makes it their fault. Responsibility is not about blame. The purpose of blame is to make someone wrong, and in interpersonal relations, it is of no useful good to anyone. It's only a tool to punish and manipulate. Legal and political systems assign blame so that there is an individual or group held accountable to make restitution, but blaming yourself is not a way to take responsibility.

Out of blame comes the idea of failure: "If I take responsibility, it means I'm wrong, and therefore I'm a failure." Being wrong and making mistakes are human qualities that no living person can avoid. You cannot be a human being without making mistakes—that is one of the qualities of our species. Blaming yourself for making those inevitable errors is not taking responsibility. When you fail at any particular task or activity, it simply means you did not succeed at that task or activity. Failing does not make you, the individual, a failure. It is not responsible to call yourself a failure, or to scold yourself about any attempt that failed. Assigning blame, calling yourself wrong and deciding you are a failure has nothing to do with taking responsibility.

So what is responsibility?

To take responsibility, accept that you—and only you—are accountable for the situation.

Responsibility is about ownership. If that awful car with the rust spots belonged to you, you could have had it hauled off or painted any color you wanted.

To get an idea of what taking responsibility looks like, follow the exercise below. You will need a pen and paper.

EXERCISE: TAKING RESPONSIBILITY

1 Think of an event, something that happened in your life. It can be a positive, joyful event or something awful or hurtful. The flavor of the event isn't important; it only matters that it was an actual event in your life.

2 Write the story of what happened, and take the point of view that this event came at you out of nowhere, that, in effect, you were an innocent victim and had no control over the situation. Be as detailed as you can in unfolding the story, and include everything that happened to you and others as a result of the event.

3 Next, write another version of the same story. Take the same event, but this time, write it as if you were in charge of what took place, as if you had somehow planned for it to happen and expected the outcome.

~

Jane did this exercise and wrote the story of a terrible auto accident that had occurred about five years earlier. Struck head-on by a large speeding truck, her car flipped upside down and landed on its roof in a ravine. Jane and her boyfriend, Larry, were badly injured. In fact, she sustained a serious head injury that cost her many months

of rehabilitation. She wrote the story of the accident, noting a laundry list of injuries and graphic details of her long and arduous recovery period. Her story ended with the sad outcome that although she and Larry healed physically, their relationship did not survive the ordeal.

It was difficult for her to reread the narrative. The story was filled with suffering and sadness, and there was bitterness over the loss of her six-year relationship with Larry, which she swore was caused solely by the accident and its aftermath.

When she wrote the second version of her story of the accident, though, something inside Jane shifted. Although at first it seemed silly to her, she wrote that she had caused the accident by carelessly pulling out of a driveway onto the highway (this was at least partly true, as she had been fined for causing the accident) and that she had brought about the accident so she could achieve a number of important—albeit private and not quite conscious—goals in her life. She noted that she had needed to make a big change and didn't know how to do it. Jane wrote that prior to the accident, she had always been a fearful person and that she did not like to be alone or to

venture outside of her neighborhood. After she recovered from the crash, she moved by herself from a small town in Massachusetts to a studio apartment in Manhattan's Greenwich Village, and two years later she moved three thousand miles away to start a new life in California.

She even recalled questioning her relationship with Larry before the car crash. About a week before that truck came along, she remembered, she had talked with a friend about Larry. It was a conversation she liked to pretend never took place. In writing the second version of her story, Jane remembered having said to her friend that day, "I don't know what will ever break us up. I wish we'd get married so we can get divorced already and be done."

As shocking as it was, even as she was writing it Jane felt something shift within her. Suddenly her ideas changed and she believed the second version of her story. She recognized deep down that she had been looking for something to shake things up in her life, and although she didn't think she deliberately caused the car crash, she could feel that it had served a purpose for her. In fact, the most important thing that had come out of the unpleasant incident was that she lived her life differently

with respect to her loved ones. In the hospital, when she learned she had almost died, she had been most distressed by the fact that she might have been forced to leave the planet without ever telling her loved ones how she felt about them. After the accident, Jane made sure—always—to let people know she loved them. She carefully parted with her friends and family, even for brief periods of time, by saying, "I love you," or simply by making sure they always knew how much she cared.

~

For his story, Ed chose an event that had happened only a few weeks earlier. He had been fired from his job and was still stinging from the hurt and humiliation it caused. He launched into the first version with great gusto. Since his emotions were still close to the surface, any little thing set him off, so this first part of the process gave him a perfect arena for venting his anger and embarrassment at being fired.

What happened was this: Ed was called to the Human Resources office by the vice president. When he arrived, he discovered that his boss, Sarah, was there too,

and he began to sweat. Sarah said, "The job you're doing has been eliminated as of today." Ed couldn't imagine what he had done to cause an irreconcilable rift in his relations with his boss and the company, and he was instantly ashamed of himself.

He returned to his desk, accompanied by the vice president, who watched carefully as Ed packed a carton with his belongings. With the entire office staff watching, the vice president escorted him out of the building, Ed's face red with mortification and the box of possessions in his arms.

There was no question in Ed's mind: he was the victim here. Prior to that terrible day he had no indication that anything was amiss; he had been doing an excellent job. Although he had only worked for the company for four months, he knew he was the best person there. There was no way this responsibility exercise would change his mind. He was the innocent injured party in this event; that's all there was to it.

When Ed began writing the second version of the story, he was confident. He knew he could not possibly be responsible for losing the job. As he wrote, though, he

did remember the problems he had had at the office. Although he was in charge of the department budget, he didn't understand it, yet he submitted page after page without any idea if they were correct. Also, he had not made a single friend in the entire four months he was there (very unusual for him) and, as a result, he compensated for feeling lonely at work by making personal phone calls.

Slowly it dawned on Ed that things had not been going quite as well at the office as he had imagined. While it took him some time to consider the idea, eventually he could see that he had received clues that his performance was not as stellar as he had been telling himself all along. He recalled not coming through on a big project and blaming people in the other departments who would not help him. He also came to realize that having a job eliminated—someone told him it was later replaced by a strictly budgeting function—was not the same thing as being fired. Actually, he had just taken the layoff personally. Once he looked at it responsibly, he admitted the truth, that he disliked the job intensely and longed to be elsewhere.

From the perspective of responsibility, you realize that you have the power to make something happen. From any other perspective, such as failure or victim, you do not. In fact, from those positions you will operate in a helpless, powerless way at the mercy of "circumstances."

It is up to you to take this first step by taking responsibility for the situations you want to change.

Even if you know absolutely—you are 100 percent certain—that you are not responsible, try this technique: pretend you are responsible. Just pretend.

Chapter Two

A QUANTUM LEAP
FROM NEWTON

*O*kay, okay," you say. "I admit it. I'm responsible. What's so scientific about being responsible? Where's the proof that taking responsibility does anything at all?"

To explain how the science works, I will need to provide some background information. The science is, of course, quantum physics and the discoveries we will encounter were made nearly one hundred years ago.

How real is our world? How solid is it? If you touch something, a tree, for example, it seems hard and real. You can run your hand along it and touch the rough texture of the bark, put your arms around it and feel the sturdiness of the trunk, and rub a leaf between your fin-

gers and notice its papery quality. The tree is dense—you can't see through it. Your own senses will tell you the tree exists. Of course it's physical, solid and real.

But is it? Most people know that everything in the world is made up of molecules. And in science class we learned that molecules are made up of atoms. But when you're up close looking at that tree, you're probably not thinking about atoms. I'm not usually thinking about atoms either.

If you and I were the ones to discover the way life functions in the quantum, we would say it is, by definition, magic. It's the stuff of fairy tales.

Let's think about them for right now, because I wrote this book to tell you about the amazing, dynamic qualities of the infinitesimal subatomic pieces that make up atoms. What's more important, I want to show you how emulating these qualities can change your life. Also, there is a chance that some aspects of these tiny entities will be as fascinating to you as they are to me.

A NEW LOOK AT THE ATOM

Maybe you have seen one of those plastic models of atoms, with a sphere-shaped nucleus in the center and electrons circling around it like planets orbiting the sun. Sometimes the nucleus is painted red and the electrons are blue, or vice versa. As it turns out, that model was wrong. What they taught us in science class is not the way it is. The electrons don't orbit the nucleus that way at all. In fact, what makes up most of an atom is space. You may also be surprised to discover that no one has ever seen a subatomic particle or even an atom, for that matter. What we can do, in experiments, is see the tracks the subatomic entities make (scientists can account for their movements using complicated mathematical equations with odd, unrecognizable symbols that mean absolutely nothing to many of us).

The atom, consisting mostly of space with a nucleus in the middle of a bunch of electrons that randomly move around all the time, is like a jiggling little creature. The way nature works inside the atom does not follow Newton's laws. Subatomic particles have their own laws,

which are different than the rules governing the normal-sized everyday things in our lives.

The world of the very tiny and very swift is known as quantum physics. Don't let that name discourage you; it's just the name scientists use so people know they are talking about tiny subatomic bodies and not regular-sized objects, such as baseballs, houses and people. Quantum physics, sometimes called *the quantum*,* is that part of science that studies the subatomic entities that are the building blocks of physical reality. The quantum concerns the world of electrons, protons, neutrons and the many other subatomic bodies that comprise the real, solid, physical parts of our world: our bodies, cars, houses, books, tables, food, trees—everything physical.

In our world, if you drop a stone, it will fall, no matter where on earth you are. It also doesn't matter who does the dropping. If you or I or anybody else drops a stone, it will fall. Newton's laws of nature are predictable; we can know ahead of time that anything dropped will fall.

*Note: Quantum physics is named for the word *quanta* used by Max Planck to describe his discovery that energy is not a steady stream. Planck found that energy works in discrete clumps or packets, which he called *quanta*.

In the quantum world, where Newton's laws don't apply, we cannot make the same kind of predictions. The quantum opens up an entirely new view of how our world works. To put the unusual world of the quantum into context, it is important to first take a look at what came before its discovery. Knowing how people used to think about our world based on Newton's model (which is the way many people still think about the world today) is essential to understanding the principles of the quantum.

THE WORLD ACCORDING TO NEWTON

In 1687, Isaac Newton wrote an article about how the world works. In a paper called "Principia Mathematica," he wrote about the ideas concerning motion in the universe that had been put forward throughout the centuries, going all the way back to ancient Greek philosophies. He put forth his own observations, known as the three laws of motion. With this paper, Newton was able to demonstrate that the world is logical and predictable.

The ideas behind his version of science, which were generally accepted among the scientific community of his day, can be summarized as follows:

1. Motion happens in a smooth, flowing way, that is, it is a steady stream of action.

2. Motion happens because something caused it to happen, namely, a cause was present. This means everything that comes to pass works like this: a cause happens, and then the resulting reaction or effect occurs. Time is what comes between the cause and the reaction or effect.

3. Motion can be broken into its component parts. Each piece has its job to do, and the parts make up the physical universe. The universe works like a giant machine.

4. Scientists can only observe what happens from a neutral or objective view, that

is, there is a single truth of reality in the universe, and nothing can alter the ultimate truth.[1]

Sir Isaac Newton taught us that what goes up must come down and other important facts about nature. People took what he said and applied it to all life, formulating opinions about the world in general. The way of thinking that resulted is called determinism, which means that everything is determined ahead of time. In other words, once something exists or has started, it will continue in a way that can be predicted, or determined, according to natural law. For example, if a ball is rolling across a table, we know—and therefore we can predict—that it will keep rolling until it reaches the edge. Then it will fall. Everyone knows that's what will happen, so we can say the ball's rolling and even its falling is predictable and determined.

According to Newton, given any starting point, we can correctly predict the outcome of an event every single time. The answers are all there, foreseeable and waiting to be uncovered by a logical, step-by-step progression.

DETERMINISM RULES

In Newton's view, the universe functions as a large machine, set in motion long ago by God. As each wheel turns, it causes movement in another piece of the machine, and that section affects another part, and so on. First the cause happens, and then the effect follows.

Physical phenomena were explained with Newton's science and, as a result, science became revered as the height of human knowledge. People looked to the scientists to provide answers, because in science there is accuracy in measuring anything, and mathematical calculations can be computed right down to the decimal point. Using Newton's discoveries as a pattern, the answer to every question, they believed, could be worked out in advance. In effect, with his calculations, Newton reduced people's spiritual, religious and metaphysical questions about the ways of our world to mere mathematical predictions.

Newton's explanation of the physical world expanded to include philosophy and people's attitudes about life, resulting in a deterministic outlook. What

determinism tells us is that since the engine of God's great apparatus has already started, all motion—and everything else in the universe—is predetermined. The machine is unstoppable, and we and all other living things are merely moving parts; we can do nothing but play our appropriate roles in His grand scheme. Like billiard balls struck by the cue stick, we will roll in a mathematically predictable way. That is, cause yields effect, and it will do so every time with consistent predictability. God's universe, then, can be considered both causal (governed by cause and effect) and deterministic (completely predictable).

Who can argue with scientific facts, proven with complicated mathematical calculations? And who can argue with God, for that matter? For every action there is an equal and opposite reaction. With determinism, everything is inevitable and accounted for. The idea of free will is meaningless, and there is no hope of improving anyone's life or doing anything to upset the status quo. Each of us, every animal, every tree, has a job to do. Like cogs in a wheel, we are merely parts in the machine, and the engine is moving forward toward its

eventual destination. There is nothing you, I, the animals or the trees can do about it.

With the Great Machine running everything, all laws must be obeyed. This idea is beautifully illustrated in an episode of *Star Trek: The Next Generation*, when cyborgs capture the captain and expect his personality and his very identity to be absorbed into the Collective, a large machine that is their world. "Resistance is futile" is how the cyborgs put it. Resistance is futile: we have no choice. Or so says determinism.

In effect, determinism takes away all free will, it steals all creativity and hope, and it abolishes dreams of the future. Seeing the world as deterministic means there is no reason to do anything as a person, a nation, a world, because nothing we do can have any impact on or alter what is inevitable. Everything has been decided by God already. People can only plod away with crossed fingers and accept whatever comes along. It is as if we are all on a conveyor belt, heading for the eventual burial plots at the end of our lives; there is nothing new to discover about ourselves or anyone else that hasn't already been taken into account.

THE RESPONSIBILITY OF SCIENCE

To be considered a science, a field of study must depend on experiments, where the proof of any scientific fact can be demonstrated through an experiment. Other fields of study—literature or psychology, for example—are not considered scientific because even psychological truths cannot be proven with experiments. Quantum physics, like regular old classical physics, uses mathematics to confirm the truth of its experiments. The scientists use complex formulae to represent what happens in the experiments, and if the math matches what happens, voila! a new scientific fact is confirmed. (Since we will be looking at the results of experiments already proven and confirmed, we are not concerned with validating the correctness of any research here; therefore there will be no mathematics in this book to prove the experiments or for any other reason!)

For many centuries, metaphysicians have known how to create their universes, but without the discoveries in the quantum, they did not necessarily know how or why their methods worked. Today, scientists know the results

of the experiments we will be exploring, but they also do not know how or why the quantum works.

Metaphysics is a word that refers to anything that cannot be observed with our five senses. It's what happens in our minds and includes all that is considered beyond, past, above or outside of what is physical. Philosophy, cosmology, the supernatural and all of psychology, psychiatry and psychotherapy are metaphysical in that they are not of the tangible, physical world and cannot be interpreted by using the five senses. Metaphysics is the study of characteristics of what is not physical or tangible: thoughts, feelings, spirituality and religions are all metaphysical. Metaphysics addresses areas of life that science cannot and describes the way nature works in ways that need not ever be proven by experiment; in reality, these vital aspects of life cannot effectively serve as the subject of experimentation.

~

All scientists are constrained; by definition, they must prove their truths by experimentation or what they practice is not considered science. Yet there are billions

of us on the planet who are not scientists and we do not need to worry about the limitations placed on people in the scientific community. We have no such restriction and we have no rule about authentication by experiments alone. For us, truth does not need to be validated by anything other than our own experience. We are not controlled in the scientific way, and for most of us, the experience of something is the best test of its truth—we can feel it, know it and sense it.

THE WORLD OF SCIENCE

The scientists who tell us how the world works are limited by rules they have to follow in conducting their experiments. One rule for scientific experiments, for example, is that they have to be repeatable. The results must always be the same, no matter who performs the experiment or where he or she conducts it. Experiments must also be objective. That means an experiment cannot be influenced by a scientist's opinions or what he or she wants to happen.

To be objective, an experiment has to just happen on its own, without the scientist altering the results or skewing them in any particular direction. Yet quantum scientists have made startling discoveries that defy conventional experimentation and the way people thought the universe worked. They have shown that simply by making responsible choices and observing certain experiments, a person can change the outcome of what takes place. This information, of course, completely negates the idea of being objective. In fact, the first principle of quantum physics is that we cannot examine anything in the quantum without changing it. Experiments have shown, time and time again, that you get one result when you observe the experiment and a different one if you don't observe it. If that idea is confusing to you, don't worry. It's confusing to everyone.

Since scientists are dedicated to measuring and recording information in a strictly neutral manner, this truth about the way the quantum works presents a dilemma for some physicists. In fact, some of them find this weird feature of quantum physics disturbing and therefore unacceptable. They may even try to twist

words to make it sound as if the quantum does not work this way.[2]

The physicists who actually made the discoveries about the quantum acknowledge Werner Heisenberg's uncertainty principle. In this principle, Heisenberg states that a person cannot measure both the position and the momentum of a subatomic particle—an electron, for instance—at the same time. As soon as you figure out exactly where the electron is, its location or position, as the scientists call it, you cause a change, and it is no longer possible to know how much momentum or force it has.

> *"The test of all knowledge is experiment. . . . Experiment is the sole judge of scientific 'truth'."*
>
> —*Richard P. Feynman*

Once you know the momentum, your measurement causes a change, and you will not be able to find out exactly where the electron is.

The subatomic world ignores Sir Isaac Newton's

classical physics logic, as can be shown in experiments described in the following chapters. In fact, the universe of subatomic entities and their workings actually support the idea of more than one world or reality. In an indirect way, quantum physics proves the idea of an individual, subjective world, that is, that each of us has our own world, our own universe, with some common overlapping truths.

The quantum, by its subjective nature, brings up numerous questions: Is there only one true way of seeing anything in life, as Isaac Newton would have us believe—that is, is there a single reality that is not influenced by people? Is there really only one correct way of viewing anything that happens in our world? Or could it be possible, or even likely, that truth is subjective and therefore different for every person who experiences it? What if it turns out that scientific truth is individual and there are as many versions of the truth, and of the world, as there are people in it? This is a controversial concept we will examine further.

The purpose of asking these questions is not for intellectual stimulation, but to look at ways to change

your life, to make your life work better by applying facts about the quantum, facts that already have been proven, both in the laboratory and mathematically. Once you learn about the ways entities in the quantum work, you will be able to use them as inspiring examples for what to do to change your life, to make your life more successful and fulfilling.

Quantum physics rules out the old ideas of determinism, and instead provides us a picture of a world, a universe, that is filled with possibilities and probabilities. Whatever a person's relationship to God, the idea of His running a Great Machine is no longer valid. We are not helpless pieces on a game board, purely diversions for a God that has decided everything already. We are not soldiers, merely marching in step to some pre-programmed orders. Rather, as quantum physics proves, the world is overflowing with potential and promise, and that changes everything. The Great Machine has not determined the outcome of our lives for us, and scientific calculations need not be involved at all. God, whether kind, generous and loving or even angry, does not want to rob us of free will in the name of determinism. We are free

to choose how our lives should be; in fact we have the responsibility to do so. Each of us is free to make our lives better and make our universe and our world more peaceful and harmonious.

> *The quantum world is a*
> *miniature of our universe.*

Everything in our physical world, our reality, is made of quantum entities: and as the experiments that follow demonstrate, your world is—literally—what you make it.

The first step in making it beautiful is taking responsibility for your life and your world.

Chapter Three

WHAT YOU SEE
IS WHAT YOU GET

*W*hat would it take to prove that people create their own worlds? How could we show that concept in scientific terms? It has actually happened through a series of experiments that took place miles and years apart.

Newton believed light was comprised of a stream of tiny pieces of physical substance, or particles. But in the now-famous double-slit experiments done in 1803, Thomas Young discovered that light operates in waves that can bump into, or interfere with, each other.

In his experiment, Young placed two screens, one behind the other, in front of a light. In the first screen he cut two slits. The light could shine through the slits onto

the second screen. He covered up one slit and saw the light shine through it and also observed a matching spot of light on the back screen. Then he uncovered both slits so the light could go through both of them at the same time. He thought he would see two corresponding spots of light on the back screen, just as he had seen the one spot when it shone through the single slit the first time. But that's not what happened. On the back screen were a series of bands of light that looked like this:

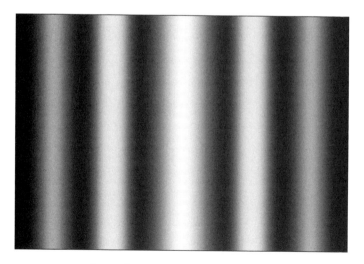

Reproduction of Young's Second Screen
with Both Slits Open

These bands of light are an indication of an interference pattern, which occurs when two waves—like waves in a pool—bump into each other. (This is a familiar effect to anyone who has ever dropped pebbles, one at a time, into a puddle. You can see that where the ripples from the individual pebbles bump into each other, the waves change. That's an interference pattern.) Based on the results of his experiment, Young proved that light is not a particle, as Newton believed, but rather it is a wave, which functions in our world the way sound does.

Naturally, the scientific community did not welcome the contradiction to the revered Newton. More discoveries were yet to be made.

Paying no heed to the discoveries of Young, as well as subsequent experiments by scientists like Faraday (who discovered that electricity could produce magnetism) and Maxwell (who discovered that changing electricity into magnetism is a reversible process and that light moves at a constant rate known as the *velocity of light*) or perhaps because they did not have exposure to the kind of global publicity we see today, the civilized world continued to exalt Newton's physics as the explanation of how the

world worked. Since Newton believed everything was determined already, his science reinforced the idea that everyone could just go about his or her everyday life without trying to make things better. Most people were not willing to give up on a science that ultimately absolved them of any real responsibility for their lives, and they continued to live their lives as though at the mercy of whatever happened to them.

In contemplating Young's breakthrough that light moves in waves, Albert Einstein studied the photoelectric effect, in which a beam of light ejects electrons from metal. In previous electromagnetic studies, it had already been demonstrated that it was electrons moving around inside the metal that caused magnetism, and since magnetism can be converted to electricity, electric current comes from the flow of electrons inside the metal. In 1905, Einstein, using Max Planck's concept of separate clumps of energy, worked with light to explain the photoelectric effect. He determined that if you looked closely enough, you would see that the waves of light were actually particles—little bits of light strung closely together, which he called *photons*. Einstein proved that it was pho-

tons hitting the electrons that triggered their ejection and caused them to release energy in the process. Einstein was awarded the Nobel Prize for his discovery that it was the collision of particles, photons and electrons that accounted for the photoelectric effect.

Young's experiment had proved light was waves, and Einstein proved it was particles. How can light be both waves and particles? Newton's laws cannot explain this phenomenon.

Slowly, news of the contradictory results seeped into society. By 1935, despite the findings above and other documented evidence to refute the classical view of physics, civilized thinkers were of two minds: most people still believed in the deterministic, mechanical view of our universe, while others embraced the new physics, the non-mechanical description of quantum. Even today this debate continues.[1]

For instance, determinism is pervasive in Western social and religious thinking. Many religions teach, and most individuals believe, that an all-knowing God decides everything, if not via a Great Machine, then certainly through other means.

And to this day, science is valued because it provides a single, absolute, correct answer. Receiving a single answer is the simple solution. A single answer does not require any thinking, or the kind of deep contemplation which might be needed to sort through levels of a complex answer. Along with this desire for a single, finite answer is the wish for that answer to be immediately available. Particularly in Western society, speed is essential: "Time is money" we are told over and over again. For these reasons and others, science, with its black-and-white, either/or mathematical facts, is revered or at least considered preferable to the gray areas of subjective studies. Determinism is founded in science and not in the arts, for example, and therefore as part of science, some version of determinism has been supreme in the minds of the masses since the Renaissance.

Despite the reign of determinism, there is a conflict. Young first proved that light works like waves. Yet Einstein proved light is made up of light particles called photons. Who is right? They can't both be right; light is either a wave or a particle, not both. Or is it?

IS IT A WAVE OR IS IT A PARTICLE?

Wave-particle duality is a fundamental paradox of quantum physics. In 1961 and again in 1989, Young's double-slit experiments were repeated. What the scientists discovered is that if you slow down the emission of light to a single photon (or electron) at a time and conduct the same experiment as Young's (with the two slits on the first screen and the second screen recording or measuring the results), the results are surprising. With one slit open, the electrons go through, just as one would expect, and leave a spot of light corresponding to the open slit. With both slits open, the interference pattern of waves emerges. How can this be? How can there be interfering waves when the photons are going through one or the other slit one at a time? It would seem that a single photon could only go through either of the slits, but not *both* of the slits, and that the single photon would be a particle. Here, then, is the paradox. When both slits are open, even though the photons are shot one at a time, the interference pattern appears, indicating that there is more than one wave present. As

illogical as it may be, the only conclusion is that individual photons do, in fact, go through *both* slits simultaneously and that "each photon interferes only with itself," as Paul Dirac puts it.[2] Light acts like a particle sometimes and like a wave at other times. Don't worry if this contradiction is confusing to you. It's confusing to the physicists, too.

And, more remarkably, this type of experiment produces a further startling result. Richard P. Feynman suggested a variation of this experiment using a very strong light source and electrons shot from an electron gun, which isolates the individual electrons. A Geiger counter is attached, and it clicks each time an electron leaves the gun. In addition, there is a flash of light as the electron passes on its way to either slit, so we can be certain we are dealing with only one electron at a time. In conducting the experiment, we see a flash at either of the two slits, one or the other, so one would conclude that the electrons go through either slit. But if we run the experiment and do not count the clicks and watch the flashes, the distribution of electrons is an interference pattern of waves. "We must conclude,"

said Feynman, "that *when we look at the electrons* the distribution of them on the screen is different than when we do not look."[3]

YOUR WORLD DEPENDS ON YOU

As we've seen, a basic tenet of quantum physics is that we cannot observe the subatomic world (with our eyes or by measuring) without disturbing it. But how can simply looking at a wave turn it into a particle? No one knows how, but that is exactly what happens. Another way of describing this phenomenon is "reality is observed."[4]

The fact that light is either a wave of energy if we do not observe it or a particle of physical substance if we do means that it's up to us: it's a choice to either observe and focus on the particle or not to observe it. The light will either show up as a particle or continue its wavelike existence based on our choice of observation. This wave-particle duality, one of the foundations of quantum physics, points to an astounding truth. Think about what

it really means. If we don't focus on the subatomic entity, it is just a free-floating wave, and if we concentrate on it and look at it, it solidifies into a particle of physical substance. Since every atom in our world is made up of subatomic entities that behave this way, what does that mean in our lives?

Just as with the particles of light, whatever we pay attention to will happen in our own world. You know how it is when you buy a new red car and suddenly start seeing a lot of red cars on the highway? It's the same phenomenon: what you focus on is what you get. Maybe you think that if you hadn't bought the new car, you would not have noticed all the other red cars. But the truth is, without your noticing them, the red cars wouldn't be there! "No," you may think, "it's just coincidence that red cars are around me." There is no scientific way to prove it, but try an experiment yourself. Think of something and then see how many times it shows up in your life. It works with cars on the highway, cooperative people, and it also works with nasty people, rusty old cars and running into slow traffic everywhere you go. You know the days when everything seems to go right and

others when everything seems to go wrong? That's you doing it! It's all about taking responsibility and owning what you choose to see.

~

> *The exciting idea about wave-particle duality is you can change what you choose to observe, and by doing so, you can change what happens.*

It's the very act of your observation, your focus, that produces the result, whether it's a light particle or a red car. Therefore the first step to changing your life is to accept that you are responsible for choosing what you observe.

In fact, our physical reality, our world itself, doesn't appear unless we observe it. Until we manifest it, our universe, like light, exists only as waves of energy, as

waves of probability. That means our universe is subjective—like Brigadoon, it shows up only when we choose to see it. If this is true, you may wonder, how much responsibility does that put on the individual person? The truth is, each person is solely responsible for his or her universe.

Does this mean we suddenly have to wish with all our might that the sun will rise in the morning so our world will be as it always was? No! It means, simply, that it is each person who makes it what it has always been. We've been manifesting our universe, doing it all along, but we just weren't aware we were doing it. How do we do it, then, since we are not aware of it? We manifest by observing, or paying attention. What a person focuses on—and pays attention to—is what will show up in one's life/world/universe.

The point is that we are the ones who are creating it: we are observing the subatomic entities that solidify the waves of energy to become the substance of our world. That means that the effects we wish were in our world can be there, and the issues we wish were gone—nasty neighbors, an obnoxious boss—can disappear, too. The

neighbors can change and become nicer, or they can move, and the boss can adjust his attitude or be promoted or transfer to another location.

The magical part of this truth is that you can cause whatever it is you truly want to show up in your life. The secret is you have to prepare for it, and preparation takes responsibility, choice and focus. Your desire may even unfold over time. Although it is not difficult, the procedure does require your attention and concentration.

THE NATURE OF TIME

*A*ll right," you might say, "our observing affects what happens to electrons and photons, and it even causes them to go through either one or both of the slits. But what if we were to observe after they had chosen which slit in the screen to go through? We could not have any impact after the fact, could we?"

This is the question John Wheeler tackled in his delayed-choice experiment. Wheeler made use of mirrors to arrange a way for the observer to view the results of the experiment *after* each of the photons in question had "chosen" its path. What he discovered was that the very act of observing—even after the decision of which path to

take had been made—determined what happened. If he observed after the fact, the photon behaved like a particle of substance, but if he did not observe, it remained in its wavelike state. That result can only mean that the photon goes back in time and makes the "observed choice." How can that be? Not even the scientists know how it works, but that is precisely what happens.

TIME IS NOT ABSOLUTE

This is yet another facet of quantum theory that contradicts Newton's physics. Experiments in the macrocosm of our world conducted using classical Newtonian calculations are irreversible, because time moves in one direction only. Time marches forward, as everyone knows. If the end result of an experiment yields an explosion, for example, you cannot run the experiment in reverse, that is, from the explosion backwards to the combustible materials before they collide. But time does not work the same way in the quantum world. In fact, in the quantum, processes are generally reversible. "Sub-

atomic particles live in a world ruled by a science that sometimes seems like science fiction," says Kenneth Ford in *The Quantum World.* "Particles can, in fact, move backward in time, and do so continually."[1]

Wheeler had also conceived of particles moving backwards and forwards in time.

Richard P. Feynman, a student of John Wheeler's, created what are called "spacetime" diagrams to simultaneously show both time and space as elements of various experiments. A spacetime diagram pinpoints both a moment in time and a position in space, and can be used to illustrate what happens, say, when an electron emits a photon, as shown below:

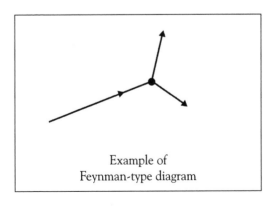

Example of
Feynman-type diagram

The spacetime diagram is read from left to right: the electron starts out at the lower left, then we see the event point when it emits a photon, which heads off in the upper right. As Kenneth Ford describes the situation:

> In the particle world, events seem to occur at exact spacetime points, not spread over space and not spread over time. Indeed, experiments indicate that *everything* that happens in the subatomic world happens because of little explosive events at spacetime points—events, moreover, in which nothing survives. What comes into the point is different from what leaves it.[2]

An interesting feature of Feynman's diagrams is that they can be read both forwards and backwards since the processes are reversible, and therefore they do not rely on time. In the quantum then, time as we know it does not exist: it is not significant, although each event does happen at a particular point in spacetime. Time is a convenience of humankind, and that fact is never more apparent than in the quantum.

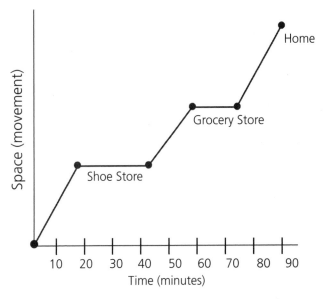

In this Feynman-type spacetime drawing, Mary leaves work at the lower left-hand corner and walks directly to her favorite shoe store, where she shops for 30 minutes. Next she stops at the grocery store, where she stays for 20 minutes. Then she goes home. In the quantum, this drawing could be read in reverse, from right to left, meaning Mary could start out at home, go to the grocery store, then the shoe store and then to work. In the quantum, both processes would be equivalent, and time is irrelevant.

~

With Wheeler's delayed-choice experiment and Feynman's diagrams, we can see subatomic bodies mov-

ing backwards and forwards in time and in spacetime, which means that time, as we know it, is not absolute. It does not exist in the way we are accustomed to perceiving it; it does not control our lives. Time is a means to an end; and the way we tell time is about keeping ourselves organized and aware. We employ time to make sense of things, to keep order. Trees are not concerned with time, nor are animals. They just are. People need time to be sure the bus shows up when it's supposed to and so they can watch their favorite shows on TV, but nature doesn't need time.

What about growth? Doesn't growing take time? Linear thinking is so ingrained in most people that they may find it difficult to consider thinking in another way. Imagine time as moving in a circle, rather than along a straight line. Perhaps it would be helpful to think of growth as a cycle, developing and then diminishing, only to be rebuilt again. If we think of this folding and unfolding as a never-ending cyclical process of development and destruction, then even growth does not require the linearity of time. Gary Zukav, in *The Dancing Wu Li Masters*, describes this idea, relating it to mythology:

Hindu mythology is virtually a large-scale projection into the psychological realm of microscopic scientific discoveries. Hindu deities such as Shiva and Vishnu continually dance the creation and destruction of universes while the Buddhist image of the wheel of life symbolizes the unending process of birth, death, and rebirth which is part of the world of form, which is emptiness, which is form.[3]

CHANGING TIMES

If linear time is not inherent to our universe, can we, too, go backwards and forwards? We do this in our minds every day, and by doing so, we keep the past—what has already unfolded—alive. There is a way to go backwards through meditation and rewrite our history, making it the way we wish it had been and thus healing whatever emotional damage has been done. By returning to the past to heal old damage, we will, in effect, alter the future.

With this kind of healing, a woman who has experienced sexual abuse in her childhood, for example, is later able to maintain a loving relationship with her husband. Healing from the past happens every day, but it doesn't just happen routinely, or with every person who has suffered. It takes focus, hard work and the right kind of support, and it may take years to repair the damage. When it happens, though, the healing changes everything that is to come.

Healing something in your past, therefore, will positively affect your future.

~

Roberto learned about this technique and found this idea exciting. His father had been an alcoholic, and whenever he drank, he treated Roberto and his mother with extreme cruelty. Although a diligent, hardworking man, the father became belligerent, intolerant and aggressive when he was drunk. When he was eight, Roberto's mother took him to live with her sister. She did this out of love for Roberto, to keep him safe. Emotionally, Roberto could not understand this decision and

was hurt by the abandonment of his parents. Once he graduated from high school, in fact, Roberto stopped speaking with both his parents. His father later died without Roberto ever having had the chance to talk with him about the past.

In an attempt to heal the old wounds, Roberto joined a group called Adult Children of Alcoholics. Although the group was helpful (at last he felt understood, and he received support from others who had survived similarly awful experiences) he longed to heal the past completely. Eventually, belonging to the group became stale for him, and Roberto thought that if he called himself an Adult Child, it meant he identified himself as an immature person. He was an adult, a man. He didn't want to be an Adult Child. In spite of the well-meaning group, Roberto yearned to heal the shame he had lived with all his life. So after learning that he could heal the damage from the past, he made up a meditation and followed it.

In a meditative state, he imagined himself in his childhood before the disruption at age eight. He saw his old room in the house where he lived with his father

and mother. He watched his father come in the door at the end of the day, and he felt the old panic, just as if it were happening for real. This time, in the meditation Roberto confronted his father. Roberto told him how hurt he was whenever his father got drunk, and how frightened and damaged his mother was. Roberto was articulate beyond his childhood self; he spoke from his adult life, talking to his father from the experience of having dealt with this shame all his life. In the meditation, his mother spoke up, too, and echoed Roberto's sentiments. Together they beseeched his father to get help and stop drinking.

Roberto repeated this meditation several times. Each time he went further with it, being more expressive with his feelings. The last time he used the meditation, his father responded positively. In this last meditation, his father apologized and explained that he, too, had survived a childhood with an alcoholic parent. He told Roberto he had quit drinking, joined AA and was getting help. He told him he had used alcohol to make himself feel superior but that he knew there was a better way of dealing with his life. He told Roberto and his mother that he

loved them and would protect them.

When Roberto came out of the meditation he felt differently about his father. Suddenly he understood that his father was a weak man, with fewer emotional resources than he himself had. The way Roberto was able to forgive his father, and his mother as well, was this: while he could not bring himself to forgive the damage they had done to him, what he forgave was the reason they did it. The meditation gave him an incentive to understand his parents; out of this understanding came compassion, and he was able to forgive them. He saw his parents objectively, as a man and a woman who had suffered and had not healed, who did not know how to repair what had happened and therefore were not capable of doing any better than they had done.

As a result of this work, Roberto reached out to his mother and reconnected with her after many years. Although his father had already passed away, Roberto's forgiveness changed the way he looked at life. He no longer saw himself as a shamed man; instead, he used his newfound compassion to inspire others to help themselves, too.

PREPARING TO MEDITATE

While there are a number of meditation types—Transcendental Meditation uses a mantra, or, word, that is repeated, and Zen meditation uses silence, for example—the meditation method we will use here is called Guided Imagery. In this book, each suggested meditation has a specific purpose, and so you will be guided through the meditation to achieve that objective.

Be sure to set aside a time and place to meditate. You'll need a quiet, comfortable place to sit, where you won't be interrupted by people entering or by phone calls. Give yourself at least twenty minutes or longer. It helps if the room is darkened, so you may want to pull down the shades or close the drapes. You may want to remove your shoes or put on a sweater—do whatever will make you feel cozy. Find a seated position that's comfortable. You can also lie down, but this may make you fall asleep. Decide for yourself if that posture works for you. The important thing is that you use a position that allows you to relax.

The following steps will prepare you to enter meditation:

1 Close your eyes gently and sit quietly for a moment. Notice your breath as it goes in and out. Feel the cushions beneath you and behind your back. Sense how securely your feet rest on the floor. Surround yourself in an atmosphere of calmness and serenity; remind yourself that you are safe.

2 When you sense it is the right moment, slowly and silently count backwards from ten to one, and with each number, feel yourself becoming more relaxed. It might be helpful for you to imagine you are walking down a flight of stairs, one step for each number you count. As you are counting, know that when you reach the number one, you will be completely relaxed.

3 When you reach number one, imagine yourself in a safe place. This place can be

indoors or outside in nature somewhere. Although it can be based on a place you have been, it is a place you will create out of your imagination. Your safe place can serve as a home base for any meditation you may want to do. See the place as you create it, or just sense it. Is it indoors, with beautiful candlelight and softness? Perhaps it is outside and you are surrounded by trees and greenery. Notice what time of day it is. What does the air feel like? What is important in meditation is that you feel; it is not important if you don't actually see the safe place, for example. Many people don't see much of anything but instead just have a sense of what's around them. Any way you experience the safe place is fine. The key is to sense you are in another place, safe and secure, which means that your mind has quieted and you are not tense.

At this point you are ready to accomplish whatever healing agenda is before you. For now, take a few mo-

ments to get acquainted with this safe place, to which you can return for any of the meditations in this book and for others you may wish to do in the future. This place is your own, and you can design it however you wish. You can change it at any time, too, if another scenario appeals to you. It's a place that is yours alone; it is just for you.

Chapter Five

INVESTIGATE & ELIMINATE

\mathcal{C} an anybody succeed in creating a wonderful life, even you? Is there anything that might prevent you from having the life you want?

The goal of the second step in the process of changing your life—Investigate & Eliminate—is to discover and disarm anything that might get in your way. By eliminating your obstacles before they become a problem, you can avoid many of the complications that might otherwise interfere with your dreams. To do this step, you need to act like a detective: the idea is to seek out and nullify as many conceivable hurdles as you can ahead of time, so they do not catch you off guard later and sabo-

tage your plans. Realistically figuring out what might prevent you from attaining your dreams later will prepare you to handle every potential road block with grace.

STEP TWO: INVESTIGATE & ELIMINATE

How do you investigate? You'll need paper and pen for this second step. What you do is ask yourself a series of questions, and put the answers in writing. Please note that there is no time limit for this or any of the remaining steps. Take whatever time you need to go through each phase of this venture. For some people this phase could take a number of intense hours and for others it could take weeks, months, or even longer. You are the one who will determine how long this step will take, and the actual timing has nothing to do with its effectiveness. You can be successful whether you move quickly or slowly. It's your choice; move at your own pace. You may want to take each phase separately. The series of questions are grouped and there are natural breaking points.

It is important to be truthful and thorough. Especially for this investigating step, writing everything down is critical. Do not try to rush through the exercises or take shortcuts by answering the questions in your head. This step won't work if you don't write out your answers; and you need to be detailed and complete. No one else has to see what you've written, so don't hold anything back, either. Set the appropriate amount of time aside to answer these questions, and put your whole self into investigating them! Since you are going to do it anyway, you might as well make this detective work an adventure. The key is to get completely involved. Immerse yourself in this step of the process.

1 *Start by asking yourself what it is you want.* What are you trying to change in your life? Maybe you want a new job, a house, more money, or a loving relationship or you want to quit smoking, or lose weight, or maybe you want to meet a partner or someone to marry; or maybe it's healing an emotional injury that you need. The change

might even concern the way you deal with people. Maybe you want to be more kind or patient, for example. Whatever the change you want right now, write it down on paper.

2 Next, *ask yourself why you want to make this change*? Don't go with your first answer, "because it's good to have money," or whatever comes to mind, as a quick response. Instead, think about it. Why do you really want it? What will it mean in your life? How will your life be different as a result of getting what you want? Be detailed. What's inspiring you to change this situation at this particular time? Has something happened to precipitate your taking action now? Have you recently seen something about your life that is pushing you to change? Be specific about whatever it is, and write it down.

3 This next question is significant, and it will stump many people. *Ask yourself*

for the reasons you don't want this change.
"Why don't I want it? But I do want it," is the instant response. Maybe so, but you need to look at every possible reason why you might not, deep down, actually want it. It may surprise you to realize that there are many more reasons for not wanting it than there are for wanting it.

~

George did this exercise about his desire for a girlfriend. He wrote that he wanted someone to love, a woman to share his life, to have dinner with and to be there for him when he needs her. He had trouble coming up with reasons why he didn't want a girlfriend. After all, didn't he talk with his friends about it all the time? Why, he couldn't have a conversation with anyone without sharing the deep yearning he had for a partner. "Nothing matters without someone to love," was how he often put it. This third question had him bewildered, in fact, until a friend made an observation, one that George met with no

small degree of resistance. His friend suggested that maybe George preferred the idea of wanting a woman to actually having one in his life.

"It's like a hobby for you, George," he said. "You do the wanting and yearning, but you never make it happen."

At first, George denied this idea (and he was pretty annoyed with his buddy for suggesting it), but after a while, he realized it really was true. He saw that he was getting something out of not having what he wanted. For one thing, he got to complain about being lonely, and he received a steady flow of sympathetic attention from his friends. A number of them had stayed awake into the wee hours of the morning with him, talking about how he could find a woman to make his life complete. Eventually, he also saw that he used the absence of a relationship as an excuse for not having success in other areas of his life, too. He was out of shape, and did not exercise or eat well. He also walked around in old gray sweatpants most of the time, acting as if his appearance meant nothing to him.

As much as he hated to admit it, even to himself, he also realized that he had been using his lonely bachelorhood as a kind of emotional club, beating up his mother

with it! He would say, "Don't hold your breath waiting for your grandchildren to be born, Mom." The more he dug for the truth, the less George cared for this exercise. Facing the truth was not what he expected; it was uncomfortable and yet, in a strange way, it was also liberating.

For clues to discovering possible reasons you don't truly want what you say you want, look to your past. Is there anything that happened in your childhood that relates to this issue? See what is there and write it down. For George, his childhood was not a good one; his parents fought all the time and then they divorced when he was nine. As a child he used to say, "I'll never get married! Being married is awful." He wrote it down and wondered if maybe that nine-year old declaration was somehow influencing him now.

A VOICE IN YOUR HEAD

Another place to look for clues is that negative voice in your head that always says you can't get what you want. It's that critical voice, the one that says

you're wrong all the time, that says you're about to fail, that you'll look foolish, and then offers a variety of other negative comments about any given thing. That voice, what I call the Dark Voice, is not truthful or accurate, but it will speak up and influence your life as long as you let it. In this case, it's important to let it speak now, so it won't get in your way later. The Dark Voice has an opinion about everything, including the change you want to make right now. "You won't find anyone to love you," George's Dark Voice told him with a sneer. Listen to what your negative Dark Voice says and write it down. That way you can make a choice about listening to it. If you don't give it a chance to speak out now, it might sneak in later and sabotage what you're creating. Giving the Dark Voice an opportunity to make its negative comments up front will disarm it.

Next, there are a number of specific reasons why you might not genuinely want whatever desire you have identified. What might get in the way is your accepting substitutions. Substitutions are what you take instead of what you say you want, and each has its own motiva-

tion. Use the following substitutions as clues to help you to figure out which of these obstacles—or others like them—might get in the way for you.

It is important to tell yourself the truth here. Remember, no one else needs to know about what you discover.

SUBSTITUTIONS

Avoiding the truth: What are you avoiding by not making the change you want? For George, the first thing he was avoiding was the responsibility of having the intimate relationship he wanted. In effect, he avoided the responsibility by living as a victim: he existed day-to-day at the mercy of the Relationship Gods, hoping they would deliver a girlfriend to him. He also avoided being honest, avoided sharing his plans and decisions with someone else, and he avoided trust—preferring to control everything in his life. He even avoided telling himself the truth about manipulating his friends with his loneliness.

Feeling sorry for yourself: It is easy to slip into self-

pity. Once you realize that you are getting in your own way and that you alone have been stopping yourself from changing your life, self pity is a natural response. Sometimes self-pity is hard to recognize, so here's a clue to see if you pity yourself: If the natural response to what you're thinking and/or saying is, "You poor thing," you're there. A way to stop feeling sorry for yourself is to pretend you arranged the situation on purpose. To try this method, George told himself, "I planned to be single at 45." After he pretended that was true, it started feeling true, and he began to wonder if maybe it really was the truth after all, thereby making him responsible for his own bachelorhood.

Blaming: Are you pretending to be a victim and putting the blame on someone or something else? George used to say all the women he met were either married or gay; so that's why he couldn't find a partner. Blaming is always simpler than recognizing your own role in the situation. For George, it was simpler to say it was the women's fault that he was alone. He also blamed his ex for the way their relationship ended. "It's her fault I'm alone," he thought.

Holding onto the past: Is there something in your personal history that connects to the changes you want to make? Is there something you want to correct before you make this change? Or are you actually trying to use the change itself to fix the past? This was a big one for George. His ex had been a woman who was married to another man for the entire duration of their involvement. He felt ashamed for having had an affair; and he never quite forgave himself. He thought that if he had a new girlfriend he could let go of feeling bad about the affair, and that the new relationship would somehow absolve his guilt over his past indiscretion.

Holding onto the past keeps it alive and gives it power in your present life. Instead of constantly reliving an old event, you can heal its emotional damage, and that healing will change you. It is you who needs to change, not the past.

If you are looking for the new change in your life to erase something in your past, it's not going to work. In the first place, the desire to fix the past will be an obstruction, preventing the change from happening. In the second place, even if you did achieve the change, you can't fix the past. The past is finished; it's completed already, over and done with. George's having a new relationship will not affect the guilt he feels over the past affair. If you are waiting to fix or heal the past before moving forward, you will keep focusing on it and you will be stuck in the very past you're trying to repair. In fact, the more you focus on something, the more influential it becomes in your life. Remember, we create reality by observing it, so if you dwell on something, it will show up before you. To get rid of something, you do the exact opposite—instead of focusing on it—you let it become meaningless in your world by changing your attitude about it.

It's time to let the past stand as is and move beyond it. Besides, you want the change to be about the future, not the past. What has already happened may have caused damage that needs to be healed, and we'll look at an effective way to accomplish that healing later. For

now, ask yourself if you want the change to correct the past. If that's true for you, accept that it won't work and move on to the next question.

Anger: Are you righteously holding onto anger or judgment instead of making the change you want? Embracing resentment and taking that righteousness as a substitution will block the change. George judged himself for having an affair, and he harbored deep-seated anger at his lover for staying with her husband. Even though she'd told him all along that she wouldn't jeopardize her marriage, George figured that he'd convince her to get a divorce. Once he failed, he never stopped being angry with her. Even now, he was most indignant about it, felt incredibly righteous, and talked about it incessantly. Having a joyful, loving relationship with a new partner would interfere with his righteous anger toward his married ex-lover. Deep down, he didn't want to give that up just yet because he was getting so much mileage out of it.

Promise: Are you looking for a promise? Promise me that when I lose weight, stop smoking, become healthy,

meet the love of my life, or whatever is your desire, that everything will be perfect and I'll live happily ever after. Looking for a promise, expecting some sort of a guarantee that this change will make everything perfect won't work either. George thought, okay, if I let go of my blame, anger, and self pity and I meet a wonderful woman, where's the assurance that having a relationship will solve all my problems? Are you going to promise me that everything will be great? No. No one can promise that. There is no assurance that life will work out the way you want it, no matter what. With or without this change, there is no guarantee. But certainly you can up the odds of your having a happy life, as we'll see on the following pages.

BINDING AGREEMENTS THAT LIMIT YOU

Another area to investigate is your existing relationships with the people in your life. Is there any unspoken agreement between you and somebody else? After his parents divorced when he was a boy, George lived with his mother. She told him many times that he was

the man of the house. "You're all I have left," she'd say. "You'll never leave me, will you, Georgie?" He promised her he'd never leave, and even though he was now an adult living on his own, George still felt responsible for his mother. In the innermost part of him, George knew he couldn't truly be happy until he'd first made her life joyful. But that wasn't going to be easy, since by this time she was living a pretty miserable existence, many miles away in another state. In fact, even if there had been a realistic way to make her life joyful, George did not want to keep some agreement he'd made as a nine-year old. If you have a limiting pact with someone from your past or your present, it needs to be nullified before you can move forward. One way to break the contract is to do it in meditation.[1]

MEDITATION TO ABOLISH LIMITING AGREEMENT

1 Once you have begun the meditation by counting backwards and finding yourself

in your safe place, you can bring into your safe place the person with whom you have an agreement that is holding you back now. If you do not feel comfortable bringing this person into your safe place, however, do not do so. In your mind, you can travel to that person or meet in some neutral location. Either way, decide that wherever you encounter this person, that the meditation will be effective for you. You are in charge, and things will go your way.

2 Imagine that the agreement is written out in calligraphy on a scroll that you read, like a proclamation, perhaps. Or maybe you see it as a legal document of some type, maybe one that looks like a lease agreement, bearing your signature. However you want to see it is fine; what is significant is that it looks official and that the paper is signed by you.

3 Take a pen that you see nearby and write the words NULL and VOID across

the page. Beneath the words, sign the document and hand the pen to the other person. Watch as he or she signs it, too. Shake hands with the person to seal the ending of your agreement and pay attention as he or she walks away. Watch silently, wishing this person well. Do not call out to the person. Allow him or her disappear from your view.

4 What does it feel like to be free of that obligation?

George did this meditation and, to symbolize his nullifying the agreement, he also wrote a quick message to his mother—one he would not actually send to her. It read,

> *Dear Mom,*
>
> *I've changed my mind about making your life joyful before I can be happy. As much as I love you, we both know you need to be on your own with your life, and I need to be on my own, too. I can't be responsible*

for you anymore, no matter how much I
care about you.

> *Love always,*
> *George*

As soon as you have answered the questions above, you are ready for the next phase. Remember: You can't fix the past . . . but you can heal its damage.

WHAT IS CHANGE?

Once you've cleared out everything that could get in the way, you are ready to begin to make the change. Some people find change frightening and try to ward it off, while others simply dislike it; yet, other people embrace change and find it exciting. Change is an important aspect of growth, and you cannot grow, physically, emotionally or spiritually, without changing.

In the quantum, change takes on an entirely new meaning. How would you approach the idea of change if you discovered that scientists have evidence that sub-

atomic entities, spontaneously, without provocation and on their own volition, transform from one kind of being to another?

As we've seen, that old planetary model of the atom we studied in school is not accurate in the quantum. Electrons do not actually orbit the nucleus in that perfect elliptical model of planets orbiting the sun. Until we observe them, in fact, electrons exist everywhere in the atom as invisible waves of energy. With our observation, electrons become particles of physical substance that have specific locations. Niels Bohr postulated that electrons also exist at different energy states, and that they change states suddenly, on their own accord. The electron in a hydrogen atom exists at one energy state, for example, and then makes a "quantum jump" to a lower energy state. The electron keeps jumping downward until it reaches its "ground state," and it does so spontaneously.[2] In spite of Newton's ideas, the electron does not require a cause to make it jump. It does it unexpectedly, without any apparent causal factor. Consequently, a quantum jump is not determined or predictable.

In the world of quantum physics, there is only prob-

ability, not certainty. There is a probability that the electron will jump, but we cannot know with precision if or when it will jump. If it does jump, we do not know which state it will jump to. In fact, as Kenneth Ford states in *The Quantum World*, "A quantum jump . . . is really a mini-explosion, in which what was there 'before' vanishes, to be replaced by what is there 'after.'"[3]

In other words, the way the electron changes energy states, suddenly and at its own discretion, is like magic. One second it's at one level, then it disappears and—presto—it reappears in a different place, at a different energy level.

Scientists believe that every possible reaction has some probability of occurring.

That every reaction has some likelihood of happening indicates that in our world anything and everything can take place, even those events we do not consider possible. Nothing is impossible! Since we create what hap-

pens by choosing what we observe, only we ourselves limit our own possibilities. It is all up to you and me. It is you who says, "I can't win; I can't get an A; I'll never be able to buy a house; I'll never find a mate . . . " Since even scientists believe that there is some probability for every single possibility, it is up to us to change our thinking and acknowledge that fact, too.

CHANGE IS INSTANTANEOUS

What we see with quantum jumps is that change is instantaneous. Like the subatomic particles that suddenly jump from one energy state to another, transforming themselves in the process, we can change, too; we can transform ourselves. When a person is truly ready to make a change—when you are ready to change—time is not involved. Ask people who have quit smoking or who have walked away from any addiction; and they will tell you. There was a moment where they were addicted, and another moment when they were free. Time comes after the change occurs, and it's over

a period of time that the effects and results of the change appear.

Change is instantaneous. Like subatomic particles that abruptly hop from one energy level to another, transforming themselves in the process, we can change, too.

It takes preparation and work to make a change, large or small, but it does not take time. Nonetheless, time is needed for us to observe and recognize that the change has occurred. Like magic, change makes what was there "before" disappear, replacing it with what is there "after." A person starts the process as a man who smokes and completes the transformation by becoming a man who is a non-smoker. The transformation happens in an instant, but of course, it takes us weeks and months to see him in his healthy new, smoke-free lifestyle.

In our minds, change happens just as mysteriously

as in the quantum. However, the results of the change, the outcomes you can actually see, unfold slowly. The evidence of breaking a bad habit, for example, shows up over time. As humans, we need proof. The woman who says, "I just quit drinking this morning," may or may not be as credible as someone who quit years ago, but we won't know for sure until we see the result become evident during the coming weeks and months. The important thing is to get into the right emotional space, the right "mindset" that will allow you to heal and change. The results, the physical manifestations of that spontaneous change, will become apparent as they unfold slowly through time. The change itself is as magically instantaneous as a quantum jump.

The Way to Change Anything in Your Life
1. Eliminate what isn't working for you.
2. Replace it with what you want.

In order to make the change and heal, you must prepare and be willing to make the actual decision.

That sounds easy, right? "Of course I want to change," you say. The decision has to be genuine; it's not about merely saying the words. If you think you really want to change and it doesn't happen, you will need to honestly examine your motivations, your convictions, and your determination.

Chapter Six

DIGGING DEEPER

*T*his next part of the process can be quite enjoyable. Using your imagination, you will generate the changes you want to see in your life, the lives of others, and in your world. There are a number of techniques you can use for manifesting what you want; and all of them rely on using your creativity.

"But I'm not creative," you might say. "I can't write or draw or play a musical instrument." For this step of the process, you don't need to be a poet, a painter or an actor. Everyone on the planet is creative enough to do this step, because each of us is already doing it. You are already creating your world every single day—and you're

doing it by simply choosing what you observe!

Until now you've just been creating and observing automatically. This method is like breathing. You don't need to concentrate on each breath, telling yourself to inhale and exhale, for instance; it's automatic. Your heart pumps blood, your stomach digests food, your other involuntary muscles all function without your deliberate, conscious instructions. The way you have been

"I'm starting with the man in the mirror. I'm asking him to change his ways. And no message could have been any clearer: if you want to make the world a better place, take a look at yourself and make the change."

—From "Man in the Mirror"
by Siedah Garrett, Glen Ballard & Michael Jackson

creating your own world has worked like an involuntary muscle. In Step Three, you begin to deliberately make the changes you wanted in your life.

Our world is made up of what we observe, using our

senses. The choice of what you observe, therefore, is up to you. In order to see the world you desire, which includes the changes you wish to make, the work begins within yourself, not with what you're observing.

~

In your own world, you are everything: you're the writer, director and lead actor in your own movie. For a movie to be satisfying and entertaining, the writing has to be imaginative, the direction clear, and the acting as dramatic or as subtle as you want it. If you want your movie to be filled with high drama, tense with nerve-racking situations, jam-packed with continuous conflict and heartache, it will be. Think of the people you know. Do any of them seem to live a series of dramatic moments, overflowing with theatrical ups and downs? The movie that person is creating is a thrilling one for all to see, despite the fact it might not be the most healthful way to live. Every single cliffhanging event causes stress for this person, and as we all know, too much stress is not beneficial to human health.

On the other hand, if you want a life of elegance and

harmony, with things working out pretty well for you and yours, you can create that movie script, too.

As with all analogies, this one breaks down at some point, and here it is. What makes a movie screenplay engaging is conflict; however, for our lives, harmony is more valuable. Just because nobody would pay money to watch a movie filled with peaceful, happy days followed by more peaceful, happy days, with everyone getting along beautifully while living in successful abundance, doesn't mean we all wouldn't prefer to live that way.

In fact, don't we all want the same thing, really? Everyone wants some version of a life filled with love, happiness, meaningful projects, success, rewarding relationships, enough money and good health so we can enjoy it all. That kind of peacefulness would make an exceedingly boring movie. But yet it makes a magnificent life.

Some people believe that it is the struggling to overcome problems, strife, sorrow, trouble and worrisome situations in life that makes us grow. It's true we can gain insight from tough times—and when we are caught up with challenging circumstances, it's always advisable

to make the most of them and learn from the experience—however, hardship and struggle are not the only ways to grow.

If you could learn through heartache and discord, or through fun and laughter, which would you choose? It is your choice. Remember, it is you who writes your own movie script. When you finish this book, you will have all the tools you need to consciously choose how you want to learn the lessons of your life.

CREATING YOUR WORLD WITH THE SUBCONSCIOUS MIND

If we're creating our world by observing and yet we are not aware of doing it, then how can we possibly be responsible for it? To understand how the process works, we need to examine exactly how we go about creating our world.

Sigmund Freud noticed that his patients' behavior seemed to be driven by motivations and experiences, most of which the patients were not even consciously

aware. As a result of studying these drives and desires that were found below the level of awareness, or subconscious, Freud recognized that subconscious factors could powerfully influence how a person behaves.

The subconscious mind is where your beliefs, attitudes, thoughts, feelings, decisions, and choices are working away, automatically crafting your life. The key is to bring what is in your subconscious mind to the surface. By bringing these aspects of yourself into your own awareness, you'll make them conscious, so you can take charge and direct them yourself.

The subconscious mind works very much like a computer program that was installed without your knowledge.

The subconscious mind is filled with every fact you ever learned, every oath you ever swore, and every belief you ever held. Its job, the function of the subconscious mind, is to craft a world for you to observe that precisely

matches all it holds. Since we don't consciously know what our subconscious minds are using as templates to create our worlds, we will need to research and discover what those blueprints are. Once we see what the subconscious mind is using as a pattern, we can change it, which in turn will produce a different result for us to observe and make real in our world.

You may find one quality of the subconscious mind particularly interesting: you can easily fool it. The subconscious mind does not recognize a difference between what actually happens in your life and what you pretend happens, by visualizing, for example. This fact is the basis for the techniques that follow and it explains why they work so well. Years ago there was an experiment done with a basketball team, which was divided up into three groups. The first group practiced as usual. The second group didn't practice at all. The third group also did not practice, but instead, they imagined that they did. The result was that the group who practiced and the group who imagined they did had the exact same outcome. The group who did nothing did not improve at all.

To put it plainly, if you convince your subconscious mind that you are becoming healthier, stronger, happier and wealthier, it will become true—because the subconscious mind will create a world for you that contains these elements. That's how the subconscious works.[1] It isn't a matter of merely saying the words, however; you have to honestly believe them. If you genuinely believe what you want is going to happen, that sincerity will convince your subconscious . . . and your subconscious will produce what you want in your world!

There are a number of ways to get in touch with the subconscious mind, and we will look at a few of them here.

One interesting and effective way to engage the subconscious is to visualize, using a meditative approach. Visualizing is a way to "make believe," to pretend that something you want is already real. It's not necessary to actually see a picture in your mind's eye, although it's fine if you do. Despite its name, visualization relies on feeling, not vision. The important thing is that you feel as if it is genuine by acting as if it is true. It is the feeling that convinces your subconscious that it's real, not the picture.

VISUALIZATION TECHNIQUE

> To experience what it is like to visualize some-
> thing, close your eyes for a moment. Think of
> what you want and pretend you have it. Pic-
> ture it in your mind, or just sense it. What
> does it feel like to have what you want? How
> excited, relieved, and joyful does it make you?
> If you don't actually see anything in your
> mind, it's all right. The important thing is that
> you feel it.

To visualize, focus on your feelings.
Just feel—pretend that it is real
right now, that it is really happening
and you have it already.

One way to engage the subconscious mind in a med-
itative experience is to pretend it is a person.

MEDITATION TO ENGAGE
THE SUBCONSCIOUS MIND

1 Once you count down and enter meditation,[2] get yourself to a safe place. Call to the subconscious and imagine a person entering your space. Personify the subconscious by picturing a person who embodies what you think the subconscious mind might look like. Be imaginative! Is it a man or a woman? Is he tall, or short, wearing glasses? Does she speak in an authoritative boom, with an accent, or is she soft spoken? What do you think your subconscious looks like? Is he messy like Pigpen from the Peanuts comic strip? Neat and orderly like military personnel? Whatever you create will be right for you; just go with it.

2 Invite him or her to join you, have him or her sit down and get acquainted by asking questions. Ask about the change

you want. "What do you think about my getting a new job?" is what Marie asked when she did this process. The subconscious mind, who for her was a tall, thin man in a business suit, told her that he believed she'd never be truly successful in her career. That was not good news at all. However, it was most informative, and once she was aware of that fact, Marie could work with it and change it.

3 In the meditation, be thorough with your questions and listen carefully to the answers. Thank the subconscious for helping you, and then come out of your meditation. Write down everything you heard.

Another visualization technique is to imagine the subconscious as a vast warehouse of knowledge or data—whatever that would look like for you. Maybe it's an actual warehouse with stacked boxes of papers, or a library filled with books, or a computer system . . .

whatever seems right to you. In your meditation, you will see the information in writing, either in lists on boxes, on index cards for books, or on the computer screen. (Remember, if you don't actually "see" anything, just sense it.) In whatever way seems appropriate, ask your question. What does your subconscious mind say about your goal? Search this place to discover what the subconscious really holds about the change you want to make. Look in the boxes, or look up the answers in books, or type in your question at the keyboard and see the answers show up on the computer screen. As soon as you come out of your meditation, write down whatever information you got.

COLLAGE TECHNIQUE

A third technique does not involve meditation at all and it can be fun and engaging. You might even want to share this process with a friend. Gather some old magazines and, keeping your issue in mind, cut out whatever words or pictures strike your fancy. For this exercise, it is

truly important not to think about why you're selecting each picture, just use whichever pictures attract you or that feel right, even if they don't seem to relate to the topic at all. If you're doing this method with a friend, you can make it more fun by helping each other. Take a blank sheet of paper and arrange the cut pieces to create a collage. Once you sense you've got everything you need on the page, you can glue, paste or even tape the pictures down. You will know when it's right. Trust yourself. Then walk away from the collage for at least a day or so, and busy yourself with other things. Go to work, watch TV, listen to some music, or talk with friends about something other than the change you want in your life.

When you return to the collage, look at what you put into it with a discerning eye. What you will see are symbols, and symbols are the language of the subconscious.

When Barry did this exercise, he wanted to quit smoking. He cut his pictures from magazines while thinking about quitting; then he glued them onto a piece of white paper in what felt like a random order. He put the paper aside and met a friend for lunch, where they got into a heated discussion about a book

they had both read. The next day he went to work as usual, and it was late in the day when Barry returned to his collage and looked at it with fresh eyes. At first, his collage looked like a mishmash of unrelated items, but when he looked closer, he could sense there was a theme. The words, "Never Say Die," served as a banner across the top. Then there was a picture of Charlie Brown's friend Linus, holding his blanket, and beside that was a picture of a woman who reminded Barry of his mother. In the next picture, a girl walked with a heavy vase on her head. There were several other pictures and words, too. "Can he do it?" was there, so was a guy working out on exercise equipment, and beside that, a football team in a huddle.

Some of the symbols were easy to interpret. Linus with his blanket didn't require much thought (cigarettes did provide some security for Barry), and he was able to make sense of everything he'd put into his collage—everything except the girl with the vase on her head. When he showed his work to his girlfriend that night, she looked at it and remarked, "So you think it's a burden to quit, don't you? It's a heavy load, right?"

Suzanne and her friend Beth spent an afternoon doing the collage technique. They met at Suzanne's house and pooled their old magazines. As each thought of her own project (Suzanne wanted a new man in her life and Beth wanted a new job) and chose pictures, she also helped her friend. Suzanne asked Beth to point out any pictures of weddings she found.

"Okay," said Beth. "And let me know if you come across the word 'manager.'" It was enjoyable to work on the collages together. When they each finished and taken time away from the technique, they got back together and analyzed their work. Between the two of them, Suzanne and Beth could figure out the meanings of all the symbols in both collages.

By identifying the beliefs and attitudes that exist in your subconscious, you bring them from the subconscious to the conscious: once you are aware of them, they are no longer hidden. Now you can deliberately change them, and your world—what you observe—will reflect the changes.

Your subconscious mind will automatically play out the details of your life for you, based on whatever program it holds. If you take charge and direct what's in there, the subconscious will create your life, and your world will be what you've chosen.

When unexpected or unwanted events occur in your world, it's because of some program(s) in the subconscious, of which you probably were not aware. The more mindful you can be about what the subconscious mind contains, the more deliberate you can be about taking charge of what happens. As a result, your world and your life can be more to your liking.

You can also be responsible by taking control of what goes into your subconscious mind today. Whenever you hear a negative or limiting comment, such as "You'll never make it on time," or "Life is just one big struggle," or one I heard in a line for the cash register, "Life is about waiting," tell yourself, "It's not true." Say the words "Cancel, cancel." That command tells your subconscious not to take the comment in and make it part of the pattern for your life. Responsibility for what you allow to enter your subconscious, becoming part of the

template for your life and your world includes everything you hear, even what is said on TV or the radio. "Cancel, cancel," works to negate anything, whether you catch yourself singing a dismal blues song or the news anchor (or an insurance company) makes dire predictions about potential disasters.

~

Kathy learned she needed an operation. Knowing it would go right into her subconscious mind and become part of her, she was concerned about what the doctors and nurses might say while she was under anesthesia. While she was unconscious during surgery, she would not be able to monitor and cancel out anything she didn't want. She spoke to her doctor about her concerns and asked that the staff be careful about what they said. In addition, the morning of her operation, Kathy thought about her subconscious mind. She addressed it directly, saying to herself, "When I am asleep for surgery, do not take in what you hear in the Operating Room. It is not to become part of the pattern."

STEP THREE: DESIGN & CREATE

Here is the step you've been waiting for; it's the step everyone wants to take in the first place—without preparation, which would definitely be putting the cart in front of the horse. If the first two steps don't create the right environment in which the change can thrive, it won't last, even when you make it happen. Once you have taken responsibility, and identified and eliminated any possible obstacles, you can begin to strategize, to design and create a game plan of sorts, a plan to produce the results you want.

EQUIPMENT AND RESOURCES

To craft a life that you want to observe and make real, you will need to have your equipment in tiptop working order and your resources and supplies lined up, clean and ready.

Everyone on the planet has the same equipment and

the same supplies with which to create his or her world. Even rich and famous people, rock stars and Oscar-winning actors, business tycoons and ballplayers, all of them have these same pieces of equipment; nobody gets any additional tools. The pieces of equipment with which we manufacture our universes are:

- *Choices and Decisions*
- *Thoughts and Feelings*
- *Attitudes and Beliefs*

Just as everyone has the same equipment, we all get the same resources, too. For supplies, you have these resources or materials:

- *Inspiration:* this is the thing you want, what you desire
- *Vision:* the picture of you when you have it
- *Anticipation:* the expectation that it will be yours

The only difference between you and say, Donald Trump, is how you use your resources and equipment

to mold your world. Every day, both you and Mr. Trump use these supplies and equipment to create your worlds; yet, your world may look decidedly different from his. Why is that? If everyone has the same tools and the same raw materials, how come everyone isn't rich, famous and successful?

There are many reasons. First of all, you will need to examine the condition of your equipment and of your resources. The tools must be sharp and ready, which means you truly desire what it is you say you want, that you have a vision of how it can happen in your life, and that you honestly believe it will happen.

Of the equipment pieces listed, the two most influential ones are choice and belief. Changing either one will produce a domino effect, impacting all the others. If you believe you can make the change, or if you choose to make it, all the other resources will fall into place. Using the information you gleaned from your subconscious mind, you can see which piece(s) of equipment you need to correct.

For example, when Barry looked at Linus with his blanket, he recognized that he used smoking in the same

way Linus used his blanket. Although he preferred to think of smoking as manly and attractive, Barry realized it really acted like a security blanket for him. In fact, he used smoking whenever he felt uncomfortable in social situations, busying himself with the ritual of getting out a cigarette and lighting it with his fancy gold lighter. It gave him something to do, an activity that gave him a purpose and made him look engaged, so he didn't feel awkward. Seeing smoking in that new perspective made it much less appealing to him. He looked at the other symbols in his collage and connected emotionally with each of them; and every single connection shifted his thoughts and feelings about being a smoker.

Barry wasn't sure he could quit, though. He knew his body was addicted and that he would crave a cigarette if he didn't smoke. Deep down, he did not believe he could quit.

Beliefs precede your reality, which means that whatever you believe is what you will create. In other words, first the belief exists, and then the corresponding reality shows up. For example, whether you believe this 5-Step Process will work for you or whether you believe it won't work, you'll

be right—because everything depends on your own belief!

The secret is to make your beliefs conscious by becoming aware of them, and to change them if they don't match your desires.

A belief is a truth that you hold in your subconscious mind. It also works like a boundary, stopping anything that does not match that belief from coming into being.

Belief = a firm conviction about the validity of an idea

We all share a belief that the sun comes up in the East and sets in the West, that the earth makes one revolution per day and orbits the sun. People also have beliefs about how the world works on a smaller scale. You might have a belief that you will never win the lottery or run a four-minute mile, or that you can't do math or get and keep a satisfying job that you really enjoy. Psychologists will tell you that whatever a person believes

will be true for him or her. Beliefs function like self-fulfilling prophecies.

For example, in his heart Dave believed, "Relationships never work for me." First of all, it seemed to be true. He'd had a series of failed relationships, two divorces, and several unhappy situations where he'd met someone great and then she either moved or met someone else. What happened was that with every failed relationship, Dave further reinforced his own self defeating beliefs. Obviously, it was true: relationships didn't work for him. It became a vicious cycle, and he eventually stopped getting involved with anyone.

A belief that works against your desires, by its very existence, will prevent you from observing what you want and that in turn will obviously prevent you from getting it. That is, the quantum waves of energy will become particles of what you don't want; in Dave's case, taking the form of yet one more intolerable woman who was not a good partner for him, or a terrific woman who already had a boyfriend, for example.

In order to attract and maintain a good relationship, Dave will need to change that belief. With a new belief,

a healthy relationship with a woman he cares for will finally be able to show up in his life.

A belief is a predictor of what will happen. If you believe you can't do something, that very belief is what will make it true. Consequently, it's important to examine your beliefs, not only to identify them, but to be intimately familiar with what it is you believe. One way to see what you believe is to look at your world. Are you succeeding at the stockmarket, being flooded with job offers, having to turn away throngs of men or women wanting to be your partner? Is everything in your life moving along beautifully? Are you living a charmed existence? No?

Everything in your life is related to and driven by what you believe. Having beliefs that conflict with your desires can be frustrating, because you won't be able to get what you want. If you want a good job and don't believe you can have one, for example, you'll be frustrated when, time after time, you fail to get a satisfactory job.

The good news about beliefs is that, while they are inflexible once they are imbedded in your subconscious, you can take them out of the subconscious, correct, tweak, change, and then re-install them.

Anytime you realize that what you want conflicts with your belief—and you can tell by looking at your life whether you have conflicting beliefs or not—you will need to change the belief, or you won't be able to succeed.

Whatever you do, don't be tempted to sell yourself short by changing your desire so that it matches the belief! It's the belief that's not working for you, and that's what needs to change. The belief is there to protect you, to make sure that your world matches the pattern it holds. Its job is to serve you. It's up to you to tell the belief what it should be—not the other way around. Always keep your dreams and your desires, hold them close and cherish them.

To change a belief, enter a meditative state[3] and visualize yourself in a safe place.

MEDITATION TO ALLOW
YOURSELF TO MAKE THE CHANGES

1 Get comfortable in your safe place. Notice what time of day it is. Take a

moment to experience the scene around you. Feel the peace that safety brings and then relax.

2 Now leave the safe place and walk through whatever new terrain you encounter. At some point, you will see a cave. Enter the cave, let your eyes adjust to the darkness, and then make your way though the rock walls, heading toward a light that is coming from around a curve up ahead. Notice how cool the air feels against your skin, the smell of the earth and how solid the dirt floor feels beneath your feet. Make your way around a curved wall, and find yourself approaching a bright, open area, lighted by some unseen source. Once you reach the lighted area, you have arrived at the place where you can change your beliefs. Hanging from a ribbon on the wall in front of you will be a scroll of parchment, like an old-fashioned proclamation, with the belief written on it, like

110

a declaration. For Barry, the statement read, "I can't quit smoking."

3 Take a big red pen you see lying on a nearby rock and write the word CANCEL in big letters across the parchment. Stand back and admire your handiwork, then remove the scroll from the wall. Rip it to pieces. Tear it apart with enthusiasm. Let the pieces of parchment pile up at your feet.

4 Next, take a book of matches that is lying on the rocks and burn the parchment to ashes. From the rocks, take a new scroll and pen that you find there, and write a new belief. "I can quit smoking," is what Barry wrote.

5 It is very important that the sentence structure of the new belief matches the old. The sentences must be identical in syntax. That is, if Barry wrote, "I am now able to quit

smoking," it wouldn't work, because the sentence structure, the syntax, is different. You want to be sure that the new belief cancels the old one exactly, so it can fit right in and take its place. Place the scroll on the wall where the old belief had been, slipping the ribbon through the top roll and making sure it is secure. Stand back and read it aloud. "I can quit smoking," Barry read the words out loud. He read it a few times, noticing that his voice held more and more conviction each time, since with each reading it felt truer. By the third time, it actually felt authentic. At this point, you can leave the cave, going back the way you came, and come out of the meditation.

~

Chapter Seven

MAKING THE
CHANGES

To reinforce the change you've made, write the new belief on a small piece of paper and put it where you'll see it often, such as on the refrigerator door, or the bathroom mirror. Every time you see the piece of paper, stop and read the words. Do it with feeling. Don't just glance at it and think, "Oh, yeah, relationships work for me," and then run out the door. Really take a moment and read the words. Realistically, it's only going to take you a few seconds out of your busy life to genuinely read those words. Read them as if you're seeing them for the very first time, as if you were in the cave again. Read them with conviction, and honestly feel that the words

are true. Make it a point, without fail, to read the words every single time you see the paper.

Once you change your belief to one that is more positive, your attitude needs to change, too—and usually with a positive belief, the attitude shift is nearly automatic. If you newly believe your life will be a success, it won't make any sense to have a pessimistic attitude about your future or about life in general. With a new belief, your attitude will become more positive. With an optimistic new attitude, your feelings will be increasingly enthusiastic and your thoughts will follow.

THE POWER OF CHOICE

You can also start at the opposite end of the matrix, by making a choice to support what you want, as long as you believe you can have it. Making a choice sounds easy: you just choose, right? Like selecting one of several, you just pick: A or B, C or D.

Actually, choice is an amazingly powerful tool for creating what you desire. It must be a pure choice, devoid of

ambiguity, bold, responsible and direct. You've got to feel it deep down; and you have to own it with responsibility.

Sally didn't know anything about beliefs, or these other resources, when she decided she wanted to get a job in New York City a number of years ago. Nonetheless, she was determined to get a good job and her determination— as she called it—was unwavering. No matter how often she was turned down or even put down (it was New York City, after all), she was still certain she would get a good job. She was going to make it happen, no matter what.

Although she wasn't aware of it, Sally had made a choice; she chose to find a job. And it worked! She ended up getting a position with a well-known corporation headquartered in the Wall Street area of Manhattan. Years later, when she learned about choices and decisions, she recognized that what she'd done was choose to find the job, even in the face of the many obstacles, critics and potential employers telling her no.

If you choose first, what you choose must be something you believe or you won't create it, although you can work effectively from choice rather than belief. In other words, starting with choice will influence the deci-

sions, thoughts and feelings, then the attitudes and fi-
nally the beliefs that you have about your having the job,
the car, the relationship, or the healing that you want.
Try this test for yourself. Think about what you want and
see if you can honestly choose to have it now, without
feeling a hint of doubt. If you can do it, choice might be
a good place to start, but if there is any trace of hesita-
tion—if you don't have absolute, rock-solid certainty that
you can have it—then start with belief.

> *Belief and Self-Image weave
> the fabric of your reality*

Another subconscious element that precedes reality
is self-image. Self-image resides in the subconscious mind
and always leads the way for the life and the world you
are creating. A person with the self-image of a loser will
create a universe where he or she loses. Consequently, it
is imperative that you discover and be aware of what your
self-image is; by doing so, you'll make it a tool you can

use consciously. Then, once it's conscious, you can decide whether you want to keep it or change it.

For example, if the self-image in your subconscious mind is that of a loser, you won't be able to win at anything important. Oh, you may win an occasional card game, theoretically by chance—even losers get a lucky hand once in a while—but it won't be a high-stakes card game with Las Vegas high rollers, a game that would set you up financially for life. If you have the self-image of a loser, you won't get anywhere near one of those high-stakes games. You'll be at home staring at a pile of bills, or sitting around your house feeling sorry for yourself, or maybe even in court being arraigned on charges of petty larceny—or something much less dramatic—but just as unappealing.

Self-Image = the way you see yourself

In order to make sure your self-image is what you want it to be, you will need to evaluate what it is right now. You have a self-image for every aspect of your life. You have a self-image at work, for example, that might be

117

vastly different from your self-image at home or with your friends. At home you may be easy going, spontaneous and flexible, while in your career you may need to be more cautious and structured, conscious of your performance and as vigilant as required to meet the expectations of your particular job.

Although both belief and self-image are precursors to your creating (by observation) your own world, they do not function in the same way. Like a bouncer at a nightclub, who prevents anyone who doesn't fit the picture of the kind of patron the club prefers from entering; that's the way a belief prevents anything that doesn't fit from coming into your life. Self-image won't completely stop something from entering your world the way a belief will, although it also must be in place first. What self-image will do is prevent something from staying in your life and in your world. You may be able to create something wonderful that shows up in your life, but if it doesn't fit with your self-image, you won't be able to keep it. The way a mismatched self-image works is that it won't allow you to keep a change, meaning either you'll lose it, or something will happen to it, or it will

turn out to have been a mistake.

One clear way to see how self-image works is with money. If you change a belief and win the lottery, for example, but your self-image is still of someone who never has enough money, you will lose the money, possibly even before you cash the check. Also, losing it may mean suddenly receiving large bills to eat up your winnings; like the person who wins $1000, and then the car breaks down en route to the bank and it costs $1759 in repairs! In other words, if you have a winning ticket but not the self-image to hold the new success, something will happen in your world to prevent your having the winnings; either you'll lose the ticket, or the numbers will turn out to be for a different day, or there will be many, many other winners, or sudden expenses will use up the winnings.

The role of self-image is especially obvious whenever you make a change in your physical appearance, such as losing weight. You may succeed and lose weight, but if you continue with the old self-image, seeing yourself as a heavy person, the weight will come right back. It is important to change and hold your self-image so that it coincides with the healthier, more slender person you have

become. With weight loss, or any other change, you need to revise your self-image to correspond with the new you, or the old you will soon reappear.

You can also see how self-image can function with relationships. If you have a self-image of a man who never gets to be with the right woman, the one who is graceful, warm and loving, then when you do have this woman come into your life, she will disappear just as quickly as she showed up, or else she'll change and turn out to be a cold, mean-spirited disappointment.

Your subconscious mind makes your world match what it holds: it dictates what you observe. To change your world, therefore, change what's in your subconscious mind.

To discover what self-image you have stored in your subconscious mind, look objectively at your life.

In order to have your world be the way it is at this very moment, what must be in your subconscious as a

self-image right now? Your world is a mirrored reflection of what's in your subconscious, so what does this world of yours replicate?

It's important to be as objective as you can when you make this assessment. If you editorialize or judge your life, that judgment will cloud your vision and it will not be clear. Just gaze from a detached view—try pretending you are looking at someone else, and use the third person (he, she) to do so, rather than the first person (I).

Anne thought, "Here's a 50-year old woman who's never really gotten it together. She's a compassionate person; she's very giving, and yet she's never accomplished anything substantial in her life. She didn't finish college or ever hold down a meaningful job. She does have a wonderful marriage, though, and a loving family and friends." She realized that she must see herself as a woman who can't do anything of value other than be a loving friend and relative, and that is what her self-image was. Once she changed it, Anne started a cottage industry designing, constructing and selling unusual craftwork, wall hangings and decorative jewelry, and she was able to achieve success. She had always dabbled in creative proj-

ects, but without a more positive self-image (coupled with the belief that she could succeed and not jeopardize her marriage), she didn't get anywhere with her work. As soon as she changed the programs in her subconscious mind, her world reflected success back at her!

To change what's in your subconscious mind, figure out what's in there—see what the program is—and then replace it with a program of your own design, one that works for you.

Until she changed the beliefs, self-image, thoughts, and feelings she held inside, Anne's external world would not change. Once she recognized the limitations she held in her mind and changed those ideas and feelings, her reality could match her (newly) honest desire for success, and she could have success without compromising the relationships she treasured.

Another way to see the impact of self-image is to look

at other people; a friend or acquaintance, for example, whose life is filled with missed connections and lost opportunities, and seems to have the self-image of an "also ran," an unnoticeable somebody who runs in the race well behind the winner but never distinguishes himself or herself. You can even be an "almost winner," one step closer than the "also ran," but still not winning the race.

Jose is a good example of an almost winner. Several times Jose has been only one digit away from the winning lottery ticket; he comes in second at any bicycle race he enters, and he is consistently the first alternate for every job or promotion he seeks. He almost wins every time. With that limited self-image, he will continue to come in second place unless he changes what's in his subconscious mind.

MEDITATION TO CHANGE YOUR SELF-IMAGE

Once you have figured out what your self-image is right now and you know what you prefer it to be, there is an easy and imaginative meditative approach[1] to changing it.

1 Enter an altered, meditative state by counting backwards from 10 to 1, imagining yourself walking down a staircase, with each number taking you one step lower. When you reach the number 1, you find yourself in your safe place. See your old self-image as a piece of clothing that you're wearing, maybe it's a coat or a jacket—or even a tattered bathrobe—depending on exactly what the image is. Stand in front of a mirror and remove the old garment. Peel it off with gusto, removing it with real enthusiasm. Say something like, "I'm done with this old image! This isn't me anymore!" or something similar. Use your own words. Throw the jacket or bathrobe in a heap on the ground and kick it aside.

2 Out of nowhere, there appears a nice new garment on a hanger: this is the jacket, coat or robe representing your new self-image. Put in on with a flourish, the way you would don a magnificent velvet cape.

124

Stride around in the new jacket—or lovely new robe—and proudly experience the new image. Observe yourself in the mirror, wearing the new you. What does it feel like to be a winner, to be the one who comes in first?

3 Let yourself fully feel that the new self-image is your own, then exit the meditation by sensing yourself back in the room and slowly opening your eyes.

~

By the way, if you like the self-image you already have, great! Own it proudly, take responsibility for it and acknowledge it.

Chapter Eight

INTERPRETING QUANTUM FACTS

*N*iels Bohr, who discovered that subatomic entities jump energy states (p. 79), encouraged other physicists to accept the paradoxes of quantum theory. From 1920–1930, Bohr debated the mysterious workings of the quantum with other scientists who came to study and work in his Institute for Theoretical Physics in Copenhagen. As a result of this open academic environment and a series of debates held at the Institute, the new philosophy, developed primarily by Bohr and Werner Heisenberg, was known as the Copenhagen Interpretation (of quantum theory).

According to this view, the laws of nature are neither objective nor deterministic. They do not describe a reality that is independent of the observer. You cannot help but affect the outcome of any observation you make, as the Uncertainty Principle tells us.[1]

~

One of the most determined to argue against the Copenhagen Interpretation, as well as about details of the quantum itself, was Albert Einstein, despite his role in its discovery via the photoelectric effect. In one series of debates, Einstein tried to find deficiencies and flaws in the basic structure of quantum theory. He could never quite accept quantum as a proper theory of physics; it was, in his mind, incomplete at best. Ingenious as his arguments and counterexamples were, Einstein was never able to come out ahead in these debates. Bohr always succeeded in disproving Einstein's concepts. These debates led to further refinements of quantum theory and to its interpretation.

Einstein is often quoted as saying, "God doesn't

play dice with the universe," as a way to disparage quantum unpredictability, but relying upon chance is not how the quantum works, as we've seen already. Perhaps Einstein felt that leaving fate in the hands of individuals was a gamble; whatever he meant, our worlds are far more subjective than he wanted to believe.

While working at Princeton in 1935, Einstein got together with two other scientists, Boris Podolsky and Nathan Rosen. The three published a paper in the prestigious *The Physical Review* entitled "Can Quantum Mechanical Description of Physical Reality Be Considered Complete?" In the scientific community, a theory is only considered complete (and accurate) if there are no contradictions in any of the experiments that prove it. A complete theory will unfailingly predict any relevant experiment correctly. The Einstein Podolsky Rosen paper (which became known simply as EPR) made an argument that quantum theory was not complete, and to prove it, the paper proposed a convoluted way to take measurements of both the position and momentum of an electron. Their argument challenged quantum theory at its very core—remember that the Uncertainty Principle, the cornerstone of quantum physics, states that

one cannot measure both position and momentum simultaneously. However, EPR argued that because of correlation, one could determine the measurement of the second electron once the first was measured, which meant that the Uncertainty Principle did not hold up.

EPR used both Newtonian physics and quantum physics to build its argument. The Newtonian part concerned the laws of motion. In greatly simplified form, the idea is that one way the scientist can make predictions is by correlating two objects that have interacted—in this case, by collision. The first object, moving at a constant momentum (or speed), collides with a second object; and we know from Newton that the second object will have the same reaction as the first to the collision, since momentum is conserved.* If we measure the position of the first object, then by correlation we should be able to compute the position and momentum of the second, which would mean that quantum

*Note: This means that the total amount of momentum (or force) must be the same before, during and after the collision. For example, if electron A has momentum 4 and electron B has momentum 5; their combined momentum will be 9. After they collide, the momentum also must be 9. If after the collision we measure electron A and it has a momentum of 6, by correlation we know that electron B's momentum, in this case, is 3.

theory is incomplete—since we would have been able to determine both the position and momentum of the second object without disturbing it at all.

Bohr was unfazed by the EPR Paradox and his response was that we cannot measure the second object, even by correlation, without disturbing it. This would mean that somehow the second object would be affected by the measurement (observation) of the first object. How could that be true?

Through a clear mathematical statement of the conflict between EPR and quantum theory, a British physicist named John Bell demonstrated that "predictions of quantum theory" contradicted the objective, cause-and-effect foundation of Newtonian reality. Cause and effect have their places in Newton's deterministic world, but not in the quantum world of subatomic particles. Bell came up with specific experiments that would make a definite distinction between quantum probability and Newtonian causality (and with it, determinism).

In Paris during the 1980s, Alain Aspect conducted a series of experiments based on Bell's proposition. He and his team used polarization rather than momentum,

because it could be done more accurately, and polarization is conserved in the same way as momentum.

> The basic idea was the same—to observe the polarization of two correlated photons (rather than the momentum of two correlated electrons), and to see whether measuring one photon had any statistical effect on the other.[2]

The outcome of Aspect's experiments was surprising to some of the physicists. Results showed that measuring the first photon did, indeed, have an effect on the second one, even though there was no way for them to communicate with each other—even by sending a signal as fast as the speed of light. Einstein called the idea of this effect "spooky actions at a distance," and yet, as Aspect proved, these effects do actually occur. The physicists call action transmitted without signals, at a distance, *nonlocality*, the same term used to describe the probability of an electron's location in the wavelength of an atom: until the waves of energy wave solidify into a particle, a single

electron is *everywhere at once*, or nonlocal.

Aspect's experiment validated the completeness of quantum theory, once again providing further evidence to dismiss the concept of causal, deterministic reality. Nonetheless, the fact that quantum theory has been proved so completely so many times, "sticks in the craw of many physicists."[3] These scientists rebel against the idea that we create our reality as we observe it,[4] and they believe there must be something out there doing it—that we can't be simply making it all up ourselves. Determinism is alive and well in the hearts and minds of many, in spite of the completeness of quantum theory. Quantum theory provides the actual, tangible proof that cause-and-effect determinism is invalid and, in fact, never was an accurate way to describe the nature of physical reality.

WHAT DOES NONLOCALITY MEAN IN OUR LIVES?

Carl Jung, a psychologist who broke away from strict Freudian tradition, considered the idea of a

collective unconscious. He described it as a level of consciousness that we all share. It exists below awareness, connects us and contains wisdom that guides all of humanity. I think of nonlocality as a way of showing the connection between all things. There is no need for communication if both polarized bodies are not separate entities but rather a part of each other . . . if everything is already connected by some invisible thread of spirituality, for example, it would account for the second photon or electron's *already knowing* what the first one did. It's like the connection between twins or other people who are very close to each other emotionally, similar to the known phenomena wherein something happens to the first twin and the other one knows it instantly, even when the two are hundreds of miles apart.

Another astounding quality of subatomic entities is that they can travel through walls. This seeming physical impossibility can be seen when an alpha particle of a nucleus decays. This phenomenon is called *tunneling* and represents a different kind of quantum jump than the one in which an electron leaps to lower

and lower energy levels. The alpha particle is held inside the nucleus by a wall of electric force that is theoretically impassable, according to Newtonian physics. "There is a certain small chance that it will pop through, emerging on the other side."[5] Although the probability is extremely low, an alpha particle can unexpectedly show up on the outside of the nucleus and fly off. It doesn't happen often, but passing through walls—unachievable through classical physics and our usual, everyday universe—can and does actually occur in the quantum.

Besides using the practical evidence demonstrated by actual tangible experiments like the ones described previously, physicists use "thought experiments" to prove their theories. Thought experiments are not actually performed in the physical reality; they take place in the mind alone: they are only hypothetical.

To demonstrate how wave-particle duality functions in our "concrete" world, Erwin Schrödinger made up a quantum thought experiment involving a cat in a lead box. In the box with the imaginary cat is a small amount of radioactive material with a *half-life* of an

hour, which means it has a 50% chance of decaying in the next hour. If the material does decay, the energy released will break a vial containing cyanide gas, and the imaginary cat will die instantly. With the lid on the box, there is no way to determine whether the cat is alive or dead, since there is an even, 50/50 chance of both. Until we open the box both realities—or positions—are actual: the position that the material has not decayed and the cat is alive, and the other position, that the material has decayed, because the exact circumstance has not yet been observed. With the box closed, we have two positions at once, called *superposition*. Only by removing the lid and observing the cat will we know what happened. Hopefully the cat is curled up asleep in the box, oblivious to the radioactive material, the vial of cyanide, and the entire cruel thought experiment. According to quantum theory and wave/particle duality, prior to our observation there is nothing inside the box but waves of energy, which will become particles (taking form as cat and vial) when, and only when, we open the box and observe what we expect to see, thus creating whichever scenario we choose.

What Schrödinger proved with this thought experiment is that the cat's condition—either dead or alive—depends entirely on what we choose to observe when we open the box. If we choose to see it happily dreaming away, that is what will be in front of us when we lift the lid, and if we want to see the exact opposite, that would be there, too. With the lid on, the cat is in limbo, either dead or alive. In a sense, she is both dead and alive, because each option is a probability until we make our observation when we open the box. With both possibilities available, we have superposition. In actuality, with the lid on, the cat doesn't exist in physical form at all; she is merely a wave of energy. It is our very observation that solidifies the waves into particles and manifests the cat, either in one state or the other.

This thought experiment reminds me of the question, "If a tree falls in the woods and no one is there to hear, will it make a sound?" No, it won't make a sound. It also won't fall. If no one is there to observe it, the tree and the woods won't even exist in the physical sense; they will be waves of energy. Whenever someone does observe the woods, the waves will con-

centrate and coalesce into particles of tree—and the tree will already be lying on the ground.

Superposition is the norm in quantum physics. "*Every* state of motion of a particle or a nucleus or an atom can be regarded as a superposition (or mixing) of other states, sometimes even an infinite number of other states."[6] In classical Newtonian physics, momentum can have only one value, and an electron orbiting a nucleus would have definable energy and momentum. Not so in the quantum.

In *The Quantum World*, Kenneth Ford describes the quantum situation as follows: "Superposition does *not* mean that an electron may have one momentum or another momentum and we just don't know which it has. It means that the electron literally has *all* the momenta at once. If you can't visualize this, don't worry. Neither can the quantum physicist. He or she has learned to live with it."[7]

Because of superposition then, it is you who will create—from your subconscious mind, with your thoughts and feelings—a personal, individual world for yourself. With the superposition of your life, every situation is possible and exists simultaneously, and it is your choice, your observation, that makes one "reality"

show up in front of you and seem real, instead of the other possibilities. That you aren't even aware of the other possibilities that exist in superposition does not mean they aren't available, as waves of energy just waiting for you to observe them.

Your world shows up only at the moment you observe it, because that is when the waves of energy fuse, taking the form of what you choose. You can use this fact to your advantage, especially when you are waiting for a response or expecting to hear some news. Since it is you who will fuse the energy waves into the response, at the moment you observe, you can take responsibility for what takes place. You can wait to open that important email message, for example, until you are in a good frame of mind, feeling confident, strong and sure of yourself.

USING SUPERPOSITION—ANYTHING IS POSSIBLE

With nonlocality, everything is connected. With superposition, anything is possible—anyplace and any-

time. Whatever you want is available to you—whether that means finally succeeding where you've failed or achieving an "impossible" dream. You can overcome enormous obstacles and beat overwhelming odds. You can heal a disease,* win a medal at the Olympics, get that fantastic job, or become rich and famous. Anything is possible.

In order to create a world that has the changes you want to see in it, as differentiated from the many possible other worlds you could choose to observe, you will need to use your own equipment and resources. The goal is to start by eliminating what you don't want, and then to sculpt your own ideas and feelings with your inspiration, vision and anticipation. That way your subconscious mind will hold what you want, and only what you want; so there are no conflicting ideas to cancel each other out. The eyes from which you observe will be clear, determined and focused, and what you observe and create for your world will be what you want it to be.

*Note: This process is not a substitute for medical help. If you use the 5-Step Process for healing purposes, be sure to continue whatever medical regimen you are on until your practitioner says to stop.

The subconscious mind works the way a computer does, storing programs and running them at the appropriate times. It is your job to be sure the programs you want—and *only* the programs you want—are present in your subconscious, since it is your subconscious that will create a world for you to observe that matches its own programs.

We live our lives as if everything around us—our bodies, houses and cars—are real and our thoughts, feelings, attitudes and beliefs are not real. After all, they're "just" ideas and emotions.

What quantum physics proves is that it's the other way around: our thoughts, feelings, attitudes and beliefs are genuine, and nothing in our physical world is concrete or real.

Physical reality is malleable and subjective. What we choose to see is what appears. It is not that the physical world is as solid, tangible and unchangeable as we've always seen it; it is that the world is completely personal and individual. Your physical world is created out of your choice and your observations alone.

The objective is to change what's in your subcon-

scious mind, to get yourself to a place of thought and feeling—a particular vibration, or resonance, if you will—so that what you see is lovely. There is nothing outside of you that can, or will, make the world the way you want it to be. Instead, the way to accomplish your goal and have what you want in your life is to work on yourself, using the equipment and resources, changing anything that might prevent you from observing all the beauty, joy and success you would like to have.

Chapter Nine

OBSERVE & GIVE IT FORM

Step Four—Observe & Give It Form—is about using your own tools and basic materials to carve what it is you want right out of "thin air."

This is the step that pulls the previous steps together. Now that you've prepared yourself, you can proceed to bring about the changes you want. I call this quantum thinking—this is the step where you will use your choice to observe and create a new world for yourself, a world that includes the changes you want. There are a number of techniques that can be used to bring what you want to fruition and into the reality of your life. You can choose which among them appeals to you.

STEP FOUR: OBSERVE & GIVE IT FORM

We know from the science that it is you who will bring the reality alive. Don't think of it as bringing something imaginary into a real world, making a physical substance where none existed before. Instead recognize that you are bringing something already real—your thoughts, feelings and your desires—into a world that looks solid, but is, in fact, only waves of energy. To work with these tiny jiggling entities vibrating at various frequencies, you can use the following manifestation technique to bring what is real (your own thoughts, feelings, dreams and desires) into focus in a world that is subject to your wishes.

As you are working with the following techniques, it might help to remind yourself of the following: The picture you have in your mind is real, and you are just bringing it into your conscious mind in a powerful way so that you will be able to observe it. Observing it is technically what makes it show up in your life.

The key to these manifestation techniques is to feel strongly, and purely, the depth of your desire for what you

144

want. It might be easier to practice on something you really want, something you feel passionate about, rather than starting small on something it would be nice to have but that's not really very important to you. The reason for this distinction is that you need to feel your desire intensely, and that will be easier if you honestly, fervently want it. Once you are experienced using the techniques, you can use them even for things you only wish would happen, because you'll know how much of your energy is required. For the first few times, though, focus on something you truly want.

MANIFESTING—
MAKING WHAT YOU OBSERVE REAL

Once your tools are clean and prepared, you can begin to build your desire, which means using your equipment on the resources to sculpt your desire and bring it to life.

Without being too attached to any particular avenue, think about how you want your desire to come to you. In other words, be sure there are channels

through which the desire can come to you, but don't limit the ways it can show up. Make sure there is an easy, logical, believable way for your desire to enter your world. For example, if you want to be accepted for admittance at a particular college, then the first thing to do is apply . . . if you don't apply, it's not very likely that you'll be accepted! Nothing is impossible, but counting on a miracle here as the starting point for this step is not a recommended way to set yourself up for success.

By manifesting, you are bringing something that already exists in your heart and mind into your own subjective universe so that you can observe it and by doing so, make it real. Give it form, depth and meaning in your life.

It is important to stack the deck in your favor: Be sure to clear the way so that what you want can find an easy path to your door. It won't be helpful to

choose a way to receive your desire that is so convoluted it will take an absolute marvel of nature and an act of God to make it happen. When you make it too laborious to receive what you want, it's called sabotage. If you notice yourself choosing an overly challenging path, or if you find yourself secretly wishing someone would just show up at your door to deliver your desire to you on the proverbial silver platter—that can indicate an ambiguity in your inspiration, feelings or beliefs about what you want, and you may wish to review the earlier steps, particularly the question concerning why you *don't* truly want it.

Joan signed up with an online dating service to meet a new man. She also willingly ventured out on many blind dates that her friends continuously arranged for her, and she was open to meeting someone anywhere else, too—such as in the supermarket or the library. Joan said she didn't care where he came from, as long as a new man showed up in her life and was someone kind, fun and honest; someone she liked. There were many different roads for her dream man to take, many believable ways she could meet

him. It took her only a few weeks to bring a very good man into her life.

~

For Tom, who wanted a new job, thinking of how it would arrive was easy. He'd posted his resume on various websites and he felt certain that the job would come to him through one of them. In fact, he was so unwavering in his idea that he would get his new job via the online services that he actually missed an opportunity offered by a friend who wanted to help. Don't do that! Don't limit yourself to a single channel, because that will narrow the possibilities.

Be aware that what you want can show up in a variety of ways; and keep yourself open to all the paths you've thought of, as well as ways you haven't even conceived. Recognizing that there are many ways in which it might appear, makes it less important in your mind how it actually arrives. What's more important is that it actually shows up in your life, by whichever means it gets there (providing, of course, that you do not compromise your principles to have what you want).

You can use the following techniques[1] to create the changes you want. You can use them or make up your own, and you can repeat them as often as you like, as often as feels right to you.

BALLOON OF LIGHT MEDITATION

1 Enter meditation by counting backwards from 10 – 1; when you reach the number one you will be in your safe place. Think of the change you want. In front of you, see a scene of you with the changes already in hand. Imagine that you have it already, and the reality of having this change is playing out before you. What does it feel like to have this change? Do you feel relieved, or exuberant, joyful, or excited?

2 You may find yourself both watching the scene and then being in it, going back and forth between the two experiences,

recognizing that you are bringing this change that you so truly want into material form.

3 Your emotions create a powerful force, so strengthen the feelings you have. This intensity of desire communicates clearly to the subconscious that this is what you want in your life and your world. As you feel more fervently, imagine a balloon of bright light surrounding you in that scene, with the change inside it. Hold the image of the balloon, inside of which is the change, and amplify your feelings—really push it!

4 See the picture of you with the change inside the balloon. Now release the image and see it float up into the sky, getting smaller and smaller as it goes higher and higher. Know that it's coming to you now, and exit the meditation.

~

Carol discovered a hard pea-sized lump in her breast. She visited her doctor, who confirmed that the lump needed to be checked and set up an appointment for her to have a mammogram. Carol couldn't sleep for the three days she had to wait for her appointment; she was frightened about the possibility that she could have cancer. Although she tried to think positively and not worry, she couldn't think of anything else for the entire three days, and her mind kept going back to the scary scenarios she'd written for herself. She replayed them over and over.

She decided to use the Balloon of Light meditation to heal the lump, whether it was benign or not. She relaxed, counted backwards and saw herself in her safe place, which for Carol is a wooded area with tall grasses that she sits in. She noticed the sky and the sway of the trees in the soft breeze that always washed over her like waves of cool air. In her safe place, she closed her eyes and pictured herself sitting in her living room. She imagined holding her cell phone in her hand. Through the earpiece, she heard the doctor's voice. He said, "Everything's fine, Carol. The lump did not show up."

Instantly she sighed with relief. How free she felt! Carol held her emotions, experienced them more intensely, and surrounded that picture of herself listening to the doctor with a balloon of white light. She experienced immense relief and gratitude that she was fine; she sensed it more and more intensely, and when it felt right, she released the feeling. At that same instant, the balloon lifted off the ground. Carol watched joyfully as it rose higher and higher into the sky. Finally, it disappeared.

When she came out of her meditation, Carol's demeanor had shifted. She exuded a calmness and serenity she had not experienced in days. Her heart no longer raced. She felt an overwhelming sense of well-being, and deep down, she knew she was okay.

Carol held that picture in her mind; it was a vignette, of her holding her cell phone and hearing the words from her doctor. She recalled the picture often, many times a day, even when she went to the clinic for the mammogram appointment. At dinner the following night, she got the doctor's call, and he told her she was fine.

"What kind of a lump was it?" she asked. He told her it was probably a cyst, since it didn't show up on the film.

It ended just the way she'd imagined it would, the lump could not even be seen on the film!

~

Jerome used the five steps because there was a promotion he wanted at his job. He bought this book with the intention of flipping ahead to this fourth step right away. Disappointed and at first reluctant, he ultimately followed the first three steps: he took responsibility, investigated and eliminated what was in his way, and by the time he got to the third step, Design and Create, he worked diligently; putting his heart and mind into what he was doing. At last, he reached this step and entered a meditative state. Jerome's safe place is a beach that reminds him of one he saw in a movie years ago. His beach has white sand and the ocean is a smooth cerulean blue. White waves crash gently on the shore; there is a warm, gentle ocean breeze. A few feet in front of him, Jerome conjured an image of his boss leaning into the doorway of his office at work.

"Congratulations, Jerry," the boss said, his hand outstretched to shake his. "The promotion is yours."

Jerome loved this image! He'd worked so hard and he longed for this promotion, which would bring him more money and greater responsibility. It was a more visible position, too, which meant the possibility of still more opportunities for advancement in the future. He surrounded the picture with a big balloon of white light, and he smiled at his elation about being promoted.

He embraced the image, squeezing hard his feelings of joy and excitement about the promotion. He intensified the feelings, more, more, and even more, and then he let them go—at the same instant the balloon, carrying the scene of his boss shaking hands with him in the office, lifted off the ground and floated upward into the sky.

Still smiling, Jerome kept his eyes on the balloon as it got smaller and smaller. Eventually, it disappeared from view, and Jerome came back out of the meditation, feeling more confident and more certain than he had in days.

Several days later, he learned that he had gotten the promotion. In fact, his boss used exactly the same words that he had visualized.

CLIFF OF CHOICE TECHNIQUE

1 Enter a meditative state by relaxing and counting backwards from 10 – 1. When you reach the number 1, you find yourself in your safe place. Take some time to notice what is around you, and experience the safety.

2 Now, you will venture beyond the safety zone. Begin walking; stepping from your safe place and following a path or road, whichever is logical for the scene. As you walk along you will encounter people or animals who may speak to you. Pay attention to everything you encounter.

3 Eventually you will come to a cliff. It is not a dangerous cliff; there is just a gentle drop beneath you. Stand safely back from the cliff's edge and look out at the scenery below. This is the spot where you will make the choice to have what you want.

4 Review everything you've done so far, the steps you've taken to get to this Cliff of Choice. Remember changing beliefs, ending the necessary agreements, and exchanging your self-image for one that supports you. Trust that while you did not do everything perfectly, you have made all the preparations well enough to create the change you want.

5 Now choose. Decide to have it. Standing at the cliff, open your arms and call out what you now choose to have in your life. State the change in a clear, certain voice.

6 Say, "I choose to be healthier now," or "I choose that a new job—or more money, or a new relationship—is coming to me now." Say it three times with certainty and confidence, letting your words echo. Seal the process by closing your meditative eyes, lower your head, press your palms together, and feel

that it is done. When you open your eyes,
open your hands, palms up, and know that
what you want is on its way to you.

~

The Cliff of Choice technique appealed to Kyle. He
liked the idea of choosing his own fate, and he used
the technique for getting accepted into the particular
graduate school program he had in mind. While his
grades should have been good enough to gain him ad-
mittance, he was concerned that he might not be ac-
cepted because he didn't feel he had enough outside
activities to qualify him, despite the fact that the school
did not deny students for that reason. He completed
the first three steps of the process and prepared himself
for meditation. Kyle's safe place is a grassy area near
some old railroad tracks—it's a place from his child-
hood, where he used to play with his brother. The
tracks are gone, now, and a parking garage is now on
that site. But for Kyle it still exists as his safe place.
Whenever he enters a meditative state, he imagines
himself at these railroad tracks. He pays attention to

the blue sky, the fluffy clouds, the overgrown grass growing between the weathered wooden tracks, and the faint scent of flowering crabapple trees nearby.

After appreciating the peacefulness of his safe place, Kyle followed the train tracks and stepped out of his safety zone. He walked along the tracks for a while, remembering the way he and his brother used to play there. A small cat approached him from behind some bushes and said, "It is okay for you to get into the program you want, Kyle." The cat did not speak in words, but somehow Kyle knew that was what she said to him. He kept walking and eventually he did come across a cliff, where the tracks just ended and the grass was much taller.

He stood at the edge and surveyed the land below. He recalled all the work he had done, both at school and in the first three steps, which brought him here to the Cliff of Choice. Kyle took a deep breath and opened his arms wide. "I choose to get into the program!" he called into the wind. "I choose that the acceptance is coming to me now." Closing his eyes, he lowered his head and brought his palms together as if in a prayer. "It is done," he thought, opening his eyes

and holding his hands palm up. "It is done!"

He came out of the meditation feeling confident. His acceptance letter did not arrive for several weeks, but the day following his Cliff of Choice meditation, Kyle saw a cat on a TV show that looked exactly like the one who'd addressed him in his meditation. Kyle took the cat as a sign that his acceptance was coming to him. For good measure, he repeated the meditation several more times until the day the letter finally arrived.

If you wish to make up your own techniques, be sure to include the following elements: intensely feel how much you want the change, sense that what you're doing in the meditation will bring it to you, trust that the preparation work you've done is sufficient, and end by knowing that it's coming to you now. Come out of your mediation and watch for the signs.

THERE ARE MANY WORLDS?

In response to the "Schrödinger's cat" thought experiment, Hugh Everett presented the "Many Worlds In-

terpretation." He proposed that in Schrödinger's thought experiment, both possible results actually do take place. That is, the cat is both alive and dead—it is just that the result we see takes place here in our world, and the other one takes place in an alternate, parallel universe.

There have been a number of explanations of the Many Worlds Interpretation, and the ideas are defined in relation to scientific experiments. These descriptions would suggest that for every experiment conducted, there are alternate, parallel universes, and the other universes apparently correspond to the number of possible results. This account of the Many Worlds Interpretation produces an abundance of alternate, parallel universes, each a carbon copy of our own, with only one difference: every one has a different result to a single scientific experiment!

To add further intricacies to this conundrum, let's consider the paradox of Wigner's friend.

Wigner's friend is someone who observes the cat in the box before Wigner gets a chance to observe it himself. She tells Wigner what she saw. Then the question

becomes: when is the decision made about the cat's survival, and whose observation is accurate?

Scientists have offered differing ideas about the Many Worlds Theory, which are based on different philosophies and measuring devices. Let's consider this dilemma from the point of view of the quantum, the subatomic level. We know that if we don't observe them, energy waves have no form; they exist as invisible waves of energy, like sound waves. When we focus our attention and observe, the waves of energy become concentrated and thus produce a particle of physical substance. It is the personal, individual choice of what to observe that creates the particular result.

Based on the quantum facts above, I present my interpretation here: when Wigner's friend observes the cat, in her world, it is either alive or not, according to what she chooses to observe. When she tells Wigner the results, he too observes and creates, by hearing that the cat is either happily alive or not. For Wigner's friend, the cat's fate is decided sooner, because she looks at the cat before she talks to him. For Wigner, the cat is alive only at the moment his friend tells him the cat's okay. In fact,

Wigner's friend could observe the cat's being dead and tell Wigner about it; but when Wigner listens to his friend, he can observe hearing that the cat is fine. Wigner and his friend each have a separate, private universe, and the waves of energy only become particles of reality at the moment each of them observes—by directly seeing or by hearing about—the cat's fate.

Taking things one step even further is Wigner's Paradox. In this thought experiment, after learning about the cat from his friend, Wigner tells his friend that she has been involved in an experiment, too. That is, the friend, the lead box and the cat are in an even larger box, of which only Wigner is aware. So then, whose observation wins?

In our everyday world, there is support for the idea of individual realities. Take, for example, a crime scene. As detectives (and people who watch television crime drama) know, eyewitnesses are notoriously unreliable. Why? It's because every one of the witnesses sees something different. When the cops finish their canvas of the area, they often say something like, "Okay, he's between 20 and 50, either black, white, Hispanic or pos-

sibly Asian, with either dark brown or blond hair, weighing between 180 and 260 pounds, and he's either 5'1" or 6'7." Everyone saw something different . . . based on his or her own choice of observation, which as we've seen, is based on individual beliefs, attitudes, thoughts, feelings, decisions and choices.

The same thing happens at an accident site. Witness stories often conflict. Why is that? Assuming everyone is telling the truth, why do the narratives differ? And when a family is reliving memories, waxing nostalgic about times long past, why does everyone remember some specific thing differently?

It's because each person has his or her own world of observation.

Thinking along the lines of the Many Worlds Theory, then, in the cases of Carol and Jerome, the outcomes might have been different, according to someone else—in other words, in another person's world. For example, Carol's husband may have believed that she required surgery before finding that the lump was only a cyst, or even that the lump could have been cancer. For Jerome's co-worker who also wanted the

promotion, things might have turned out in just the opposite way. In her world, for instance, she could have gotten promoted and not Jerome.

With the Many Worlds Theory, we each have our own subjective universe. Since as individuals we make everything real at the moment we observe it, it would seem to follow that these circumstances can actually occur. If the Many Worlds Theory is true, the other applicants for that job you want don't actually exist . . . in your world anyway. In other words, you may know about them, but the applicants are not real for you, in your world. You can decide, therefore, whether you are in the right space, whether you are prepared, using your equipment and resources, to have the job become real in your world; it has nothing to do with being more suitable than the other job candidates.

HOLOGRAM THEORY

To support these quantum physics concepts, there is a theory based on the hologram structure of the human mind and the physical universe.

Both human memory and the quantum description of the universe share a property in common. Every part contains information about the whole, as in a hologram. Memory is not localized but spread out or diffused in the brain. The wave function of an electron gives a very small but finite probability that the electron can be found anywhere in the universe. Thus, all wave functions overlap, and all things refer and relate to each other. In a hologram, unlike an ordinary photograph, any section can be cut out and used to regenerate the whole image. Each portion of the hologram contains information about the whole.[2]

WHAT GOES AROUND

There is a saying you may have heard, "What goes around, comes around," and it's generally under-

stood to mean you will reap what you sow; that which you give out is what you will get coming back to you, the way a boomerang does.

Based on what we've learned from the science in this book, you may guess that neither the statement nor its interpretation are true—in the sense that the phrase implies some sort of automatic system that delivers energy back to you in the form you gave it out. As we've seen, there isn't any external system at all, automatic or not.

Another concept like this one is karma, which is often described as a similarly automatic system. Since each of us is creating and observing our own world of reality at any given moment, it does not make sense to think there is a system that chooses for us—an external system would, in effect, force an observation on us. There is no such external system . . . that's why determinism isn't accurate. But determinism, which some people call fate, is appealing to anyone who does not want to be responsible. Of course, like it or not, a person is still responsible for observing and thus creating his or her own world. But with fate, he or she can throw arms to the air and claim to be an innocent victim.

If we so choose, we can put out negative, hurtful energy, and although it would be logical in a linear way for us to get punished for it, we might or we might not—it all depends on what we choose to observe, based on what programs are in our own subconscious mind. No one is keeping track of who is naughty and nice and then doling out the appropriate punishment or reward. It is not recommended to take the path of negativity, however, since positive energy is so much more constructive. It is also much more fun. Not to mention that operating with malice and destruction in mind is quite a gamble, since, of course, it is not possible to exactly account for every program, every belief, or every attitude that's in your subconscious mind. Most of us have beliefs that would make it impossible to deliberately hurt others and not get punished for it.

Conversely, we could put out positive energy, helping others, donating to every charity around, volunteering at hospitals and homeless shelters, generally acting the way a good, generous person acts, and still not get that job we want. What comes around is what you let come around, by your own choice of observation. You

are always free to choose, no matter what you've done in that past or what activity has come before this moment.

Even if you've done something about which you are truly ashamed, you can forgive yourself completely and use these techniques to have a wonderful life—in spite of anything in your past.

Chapter Ten

GIVE IT MEANING
& MAKE IT MATTER

*O*nce you have followed Steps 1, 2 and 3 and used the techniques in Step 4, you should see results, or at least a sign that results are coming to you, usually within 72 hours. Step 5 is about results, and you need to watch for them.

Be open to seeing "signs," which might show up in a variety of ways. A sign might be the words to a song on the radio or something you notice in the newspaper; someone could say something to you, etc. Signs can come from anywhere and the idea is to be prepared to see them. If you are watching for signs and clues and expecting them, you will be more likely to spot them

when they come along. As soon as a sign (or the actual thing you want) shows up, it is time to engage Step 5.

The thing you want may or may not show up in the exact form you planned. Be open to something that's even better than what you originally wanted. What you wanted may be in a completely different form . . . or maybe what you wanted will take a little longer to reveal itself. Remember, every conceivable scenario is possible, even developments of which you cannot conceive, so be willing to accept whatever appears.

STEP 5: GIVE IT MEANING & MAKE IT MATTER

When you receive the job, the relationship, or the healing, take a few moments and recognize how it came to you. Think about what you did to create this achievement. Acknowledge that you called this success to you, and consider how you did it. Be responsible! This is your success; so own it. What does it mean to you to have this accomplishment, this victory? For those who have a loving relationship with God—no

matter the faith or the name of the one that you call God—this is the time to experience gratitude for what you've been given.

While acknowledging the work he'd done in creating and manifesting the kind of physical healing he needed, Curtis also recognized that without God's love, it would not have happened. He stopped the car on his way to meet his girlfriend and pulled over to the side of the road. He closed his eyes and said a prayer of thanks. "I know what I did to visualize and then observe this wonderful healing in my life." He prayed, "and I know it was with your blessing, God. Your love is what made it all work. My ever-improving health is your gift to me, and I thank you."

Take time to consider what this new success means to you. How will your life be different, now that you've achieved this victory and gotten what you wanted? What approach will you take the next time you want to change something in your life?

Bridget got a great new job using the process and was beside herself with happiness. She decided to use the same method in other areas of her life as well, start-

ing with her relationship with her two daughters; it was good already—and she wanted to make it even better.

~

DON'T GIVE AWAY YOUR SUCCESS

Don't give your new success to your Dark Voice, which will tell you that you're special, you are better than anyone else, and that you are the metaphysical King of the World. That Dark Voice lies to you and separates you from other people. If you were special and better than everyone else, then you would be separate—and being separated from others is not your goal, is it? You aren't special, anyway; you just operated in harmony with quantum physics, the building blocks of the universe. You are unique, however, and your world is one of a kind. Others may have universes that look similar in some ways, but your world is distinct to you.

WHY IT DIDN'T WORK

If three days have passed and you don't see any out-

come or any sign that your results are coming, the first thing to do is recheck yourself in the first three steps. Be certain you haven't missed something. Start from the beginning and review your work. How confident were you that the process would work? Remember that you create the answer at the moment you see or hear it, so when it is possible, return that important phone call when you feel positive and sure of yourself, not when you are filled with doubt or tired after being stuck in slow traffic for an hour. After carefully verifying that everything was done accurately and whole-heartedly and that you didn't skip a step (maybe to avoid some responsibility or even to try to shortcut the process, for example), use one or more of the manifestation techniques again. You can use the same one(s) you used previously, or try a different one; you may even want to use more than one technique this time. Remember, you are reprogramming your subconscious mind and it may need a little more attention than you originally anticipated.

If the techniques still don't work and you don't get the results you want, then it probably means some-

thing else is going on. What that something is may or may not become apparent to you—either right away or at some point in the future. The 5-Step Process and the techniques will work, so if you don't get the outcome you desire, either your resources and equipment are not clean and clear or there is a reason that it would not be beneficial for you to get the result you want at this time. "What does that mean?" you may wonder. "Is there some other step I wasn't informed about?"

There is another influence involved, over which we do not have control and for which we cannot take responsibility. The other power that can have an effect on this process is the power of God, usually through your Higher Self (that part of you that is closest to God). Your Higher Self sees the larger picture and may have more information about what lies ahead than you are consciously aware. How it can work is if your Higher Self has a plan for you that is better, or all together different, from your current desire, you may not be successful at creating exactly what you've worked on.

If this happens, do not lose heart! Take a step back and consider other possible options. See if you can figure out why it might not be good for you to have this wish come true at this particular time.

Jim was very disappointed when he used the five steps and could not create a job he really wanted, a position that involved coordinating the transportation of large computer systems across the country, from the manufacturer to customer locations. He couldn't imagine why he didn't get the job: he'd been careful about following every single step and he was certain he wanted—and truly needed—this position. A week after the job slipped through his fingers he got a much better job, one that had not even been on the horizon before. The job he got paid him more money and it had a greater potential for advancement. Additionally, he read in the newspaper several months later that the original company had gone into bankruptcy and was in the midst of a massive layoff. He realized that, despite his Higher Self's having a hand in his getting the right job, the work he did had been integral to the process.

Remember, the responsibility is yours. It does not simply get turned over to your Higher Self.

~

For Marianne, the reason she could not get a particular job was never apparent. She had interviewed for the position and she wanted it: the salary and benefits were great, and, although the work was not challenging or even interesting, she thought the job would provide her with the security she wanted. The organization hired another candidate. Several months later, the same group called her back to interview again. It seems the person they hired previously had just moved out of the area, and they wanted to speak to the top four candidates from the previous round of interviews.

Realizing she had been given a second chance to make things right, Marianne pulled out all her notes and started from the beginning of the 5-Step Process. She went through each of the steps as carefully and honestly as she could. Well prepared and impeccably dressed, she arrived early for her appointment. This time she noticed how much she disliked the man in charge of the depart-

ment, and she saw that the offices were not particularly pleasant. In the meeting, the department head asked her if she realized she had only a one-in-four chance of being hired. Politely she said yes, although she wanted to say that would only be true if they were using a random selection method to choose the new employee. Again, she didn't get the job! Although the true reason she wasn't hired was never completely obvious to her, years later she recognized the fact that the job would not have been right for her. Looking back, she clearly saw that the job would have become tedious very quickly; she would have disliked working with the department head, and she never would have stayed.

Remember, there are no guarantees. The 5-Step Process does work, and when it doesn't produce the results you want, and you have been honest with yourself and thorough with your work throughout the process, it is time to trust that something else is going on—something that may not be clear at the time, and something that we may not ever know with certainty. If the reason you don't get what you want is not apparent, it is probably not important for you to know why at that particular time.

Nothing is perfect, and like other human activities, these steps cannot offer perfection. If you don't get what you want, trust. Know that if you did the five steps with all sincerity and still did not get your result, maybe something even better is coming to you, something that may not even be on the horizon yet.

QUANTUM PHYSICS, GOD AND YOUR SPIRITUALITY

How does quantum physics and the magical way it functions fit in with your concept of God and your spirituality? Some people believe that taking action to get what you want is a sin; in fact, some religions teach that even to want something for yourself—just having that desire—is a sin. While wanting may be a sin according to these religions, it is a human condition to want more, to want better, both for ourselves and those we love. To want is natural, even as we appreciate what we have already. Because we ate breakfast this morning doesn't mean we will not want dinner tonight, too.

What we are doing is working with a system of manifesting that was created by God, if you want to think of it that way. That most people were not aware of the system does not make it anti-religious! You can believe in God by any name and still use the 5-Step Process to create a better world for yourself, for those you love, and for everyone else, too. In fact, I believe that it is because of God's love and with His blessings that the steps work.

On a spiritual level, positive energy—which essentially is love and relates to God, by whatever name you call Him—is more powerful than negative energy, so it takes only a small amount of positive energy to stop negativity or evil intent.

Although during the 9/11 crisis, the heroes on United Flight 93 were not able to save themselves, they defeated the terrorists and thwarted their plans. On that terrible day in September 2001, it wasn't merely that the passengers outnumbered the terrorists that made them successful; it was that each of the heroes on that plane made a positive choice. When they learned about the destruction at the World Trade Center, after their own

plane was highjacked—they decided that they would not allow another disastrous blow to our American way of life. They made this decision either consciously—like those who actually overtook the terrorists—or subconsciously by their emotional support. All indications are that Flight 93 was headed for Washington, D.C., with a target of the Capitol building or the White House, where it would have killed more innocent people and possibly caused a delay in our governmental process (if Senators or Representatives were injured or killed, the elections needed to select replacements could have taken weeks or months). By their choice and by their actions, those passengers refused to allow another catastrophe to happen; they would not let themselves be used for such evil actions. Further, they chose to overtake the terrorists in a rural area where no one on the ground would be hurt, even though they were not able to save their own lives.

I believe the outcome on Flight 93 would have been the same even if there were only a few passengers involved in the uprising, because their fierce determination of positive force was stronger than the destructive, negative and evil energy of the terrorists.

Another example is the inspiring story of the safe return of the Apollo 13 astronauts, after an explosion severely damaged their spaceship during its failed attempt to reach the moon. While there were literally thousands of people working to save the three men, I believe it was the sheer positive will of Gene Kranz, NASA Flight Director (the role played by Ed Harris in the 1995 Ron Howard movie "Apollo 13"), that was pivotal in bringing them back alive and well. In an interview, Mr. Kranz commented that he liked the way Ed Harris portrayed the character, particularly in showing that "the buck stops here" is an apt description of the Flight Director's responsibility. "Failure is not an option, people," is his most famous line in the movie. Gene Kranz's unwavering decision that these men would return safely—in the face of seemingly insurmountable problems—is what led everyone else to come up with highly intricate and innovative solutions to the incredibly challenging obstacles. The success of this spur-of-the-moment race to save the astronauts can remind anyone who knows the story, that all things are possible; and it was the victory (they called it a "successful failure," in that the mission to reach the

moon failed but the astronauts returned safely) that makes it such an exciting and uplifting story.

When you build an architectural arch, the stone at the center of the curve is called the keystone. It is what holds the entire arch together . . . without it, the arch will not stand. As Flight Director, Gene Kranz was the leader, and I believe it was his single, unyielding choice, his vision that the men would not perish, that corralled and unified everyone else's desire; and he was the keystone of the rescue.

~

Barbara, who lives in the San Francisco Bay area, used the five steps during the 1989 Tiananmen Square crisis in China. Three times, she visualized that the soldiers would not injure the students during the protest. After each of these visualizations, the soldiers stepped back and allowed the students to continue. The next news item she read, however, told her of the tragedy that ended the standoff. Remember that we can't know everything. What she did mattered, and it worked three times, and each time people in the world

read about these peaceful encounters amid the turmoil. That it didn't solve the crisis completely does not take away from the success that did take place.

Barbara understood that for world events like this one, where the worlds of numerous people overlap, she was one of many people all over the planet who wished for a peaceful outcome, and that visualization did succeed three times. Like the examples of Flight 93 and Apollo 13, there can still be grand success, even in the depths of failure.

PHYSICS TO MAKE
EVERYTHING WORK BETTER

What quantum physics shows us is that we are each materializing our own worlds as we observe them. By taking responsibility for that fact, we can change what's there, we can eliminate what we don't want and create and reveal what we do want. Our powers of observation are based on our beliefs, attitudes, thoughts and feelings, decisions and choices, for which we are totally responsible.

Young's experiment showed us that our world is made of waves of energy and Einstein demonstrated the fact that the world exists in the form of particles of substance. As we've seen, both are true. Together their experiments prove that until we observe it, the world exists only as waves of energy; after we witness it, our individual, personal worlds become "real," solidifying into our own physical reality. Despite many overlapping similarities, your world and mine can differ significantly. We all know people who see the glass as half full and others who perceive it as half empty. As we've learned with the quantum, it is your own choices, decisions, thoughts, feelings, attitude and beliefs that impact not only the way you see your world, but also how it actually unfolds before you: You create how and what it actually is.

Before you observe it, then, your physical world consists of energy waves, holding every possibility and capable of allowing everything possible to happen. Scientists can even predict the probability of each such occurrence. Once you observe it, you solidify the waves of energy, with all their possibilities and probability, into a single point or particle of substance that becomes something real in your world.

184

IT ALL DEPENDS ON YOU

The secret and the power is that everything is up to you.

If you choose to think that what is in this book is far-fetched nonsense, or if you believe that quantum physics is a science of statistical probability that in no way reflects how the world works, then that is what it will be for you. In fact, if you prefer, you can certainly live your life as if determinism, or fate, is alive and well. Many people do live life this way. You can allow your unexamined beliefs, attitudes, thoughts, feelings, decisions and choices to continue creating the substance of your world. If you choose, you can see yourself ever at the mercy of an external world you cannot affect. You can refuse to believe that a lack of awareness allows old programs in your subconscious to create your life.

~

As we have explored here, the other option available to you is to honestly take responsibility for yourself, your life and your world. Choose to believe that this process

will work, whether you have an understanding of the science behind it or not, and it will.

People who choose to see themselves as winners get the prizes in life. You can choose to be a winner and get the prizes, too.

With responsibility, what you observe and create will be different than it was before you became aware. With new beliefs come new and different attitudes, new thoughts and feelings, and a brighter future than you previously imagined for yourself and your loved ones.

The outcome can change and your world will be different. It's all up to you.

There are only two ways to live your life:
One is as though nothing is a miracle.
The other is as though everything is.

—*Albert Einstein*

The 5-Step Process to a Quantum Life

NOTES

CHAPTER TWO

1. Wolf, Fred Alan, *Taking the Quantum Leap*, p. 56.

2. In fact, John Polkinghorne, in *Quantum Theory*, attempts to devalue the role of the observer. On page 91, he states: "The general definition of measurement is the irreversible macroscopic registration of the signal of a microscopic state of affairs. This happening may involve an observer, but in general it need not." What Mr. Polkinghorne does not take into account is that the *measurement* is the observer: we can perceive either directly, using own five senses, or by using various mechanical measuring devices.

CHAPTER THREE

1. Wolf, Fred Alan, *Taking the Quantum Leap*, p. 59.

2. Goswami, Amit, *The Self-Aware Universe*, p. 69.

3. Feynman, Richard P., *Six Easy Pieces*, p. 129.

4. Lazaris, San Francisco Workshop, March, 1995. It was from Lazaris that I first learned about the mysterious ways of the quantum. Many of the definitions and procedures I offer here are consequential to, and derived from, what I learned from him.

CHAPTER FOUR

1. Ford, Kenneth W., *The Quantum World*, p. 85.

2. Ibid.

3. Zukav, Gary, *The Dancing Wu Li Masters*, p. 241.

CHAPTER FIVE

1. See page 57 for instructions on entering meditation.

2. In Kenneth W. Ford's *The Quantum World*, there is an excellent illustration of the electron "cascading to a lower energy state," as if going down a staircase, p.109.

3. Ford, Kenneth W., *The Quantum World*, p.116.

CHAPTER SIX

1. Lazaris, *Discovering Your Subconscious*, audio cassette, www.Lazaris.com

2. See page 57 for instructions on entering meditation.

3. See page 57 for instructions on entering meditation.

CHAPTER SEVEN

1. See page 57 for instructions on entering meditation.

CHAPTER EIGHT

1. Jones, Roger S., *Physics for the Rest of Us*, p. 180.

2. Jones, Roger S., *Physics for the Rest of Us*, p.188.

3. Jones, Roger S., *Physics for the Rest of Us*, p. 189.

4. Fred Alan Wolf, author of *Taking the Quantum Leap*, is a notable exception. He appears in the movie *What the Bleep Do We Know!?* and he teaches workshops for the non-scientist on the subject of creating your own reality.

5. Ford, Kenneth W., *The Quantum World*, p. 123.

6. Ford, Kenneth W., *The Quantum World*, p. 227.

7. Ford, Kenneth W., *The Quantum World*, p. 228.

CHAPTER NINE

1. See page 57 for instructions on entering meditation.

2. Jones, Roger S., *Physics for the Rest of Us*, p. 218.

GLOSSARY OF TERMS

Bohr, Niels: Established the Institute for Theoretical Physics in Copenhagen; debated concepts with Einstein, discovered that subatomic entities jump from higher energy states to lower energy states and, with Werner Heisenberg, developed the Copenhagen Interpretation of quantum physics.

Causal: Newtonian concept that there is a predictable, objective and logical reason for every physical action and reaction in the world.

EPR: Einstein Rosen Podolsky article, published in *The Physical Review* in 1935, entitled "Can Quantum Mechanical Description of Reality Be Considered Complete?" The article questioned the validity of quantum physics.

Determinism: A fatalistic philosophy of life that emerged

195

from Isaac Newton's principles of motion. Determinism decrees that all of life has been predetermined and can only follow a prescribed course of action.

Einstein, Albert: Helped discover the quantum through his Nobel-prize winning experiment proving that photons were particles; later became uncomfortable with the probabilistic nature of the quantum and never completely accepted quantum physics as correct.

Everett, Hugh: Created the Many Worlds Interpretation to Schrödinger's cat thought experiment.

Guided Imagery: A type of meditation in which the participant is guided, usually with a specific purpose, such as healing.

Heisenberg, Werner: Created the Uncertainty Principle, which states that one cannot simultaneously measure both the position and momentum of quantum particles; he was later instrumental in developing the Copenhagen Interpretation of quantum physics with Niels Bohr.

Loser: A person who fails to achieve goals and repeatedly comes out behind in many situations.

Many Worlds Interpretation: Hugh Everett's interpretation of Schrödinger's cat thought experiment that states the results will be different for each person, as he or she creates his or her own universe or world.

Metaphysics: Anything that is above, beyond or outside of the physical reality that is measured by the five senses alone.

Planck, Max: Early physicist who coined the term quanta, referring to the pieces of substance he believed made up the physical world.

Photon: Einstein's word for the little bits or quanta of light strung together; photons are particles of light.

Quanta: Max Planck's term for the tiny particles of substance that make up our world.

Quantum Leaps: Spontaneous hops an electron makes,

going from one energy state to another, lower energy state. Quantum leaps continue until the electron has reached its ground state, the lowest possible energy state in the atom.

Quantum Physics: The study of subatomic entities.

Schrödinger, Erwin: Quantum physicist who worked with wave-particle probabilities and superposition and created the famous cat-in-a-lead-box thought experiment, which was named for him.

Spirituality: A person's relationship to God.

Superposition: The state at which the outcome is unknown and several possibilities exist simultaneously.

Uncertainty Principle: Heisenberg's discovery that one cannot simultaneously measure both the location and the momentum of an object in the quantum.

Victim: An innocent injured party; a person who accepts no responsibility for a given situation.

Visualization: Using the imagination to conjure a mental picture, with corresponding feelings about something that is not physically present.

Wave/Particle Duality: Subatomic entities exist either as waves of energy or particles of substance, a seeming paradox that is a fundamental in quantum physics: If and when we observe them, waves of energy become particles of substance in our physical reality.

Winner: A person who achieves goals and repeatedly comes out ahead in many areas of life.

Young, Thomas: His experiment with light proved that light operates as a wave.

BIBLIOGRAPHY

Feynman, Richard P., *Six Easy Pieces*, Basic Books, Cambridge, 1995.

Ford, Kenneth W., *The Quantum World, Quantum Physics for Everyone*, Harvard University Press, Cambridge and London, 2004.

Gawain, Shakti, *Creative Visualizations: Use the Power of Your Imagination to Create What You Want in Your Life*, Nataraj Publishing, a division of New World Library, Novato, 2002.

Goswami, Amit, *The Self-Aware Universe: How Consciousness Creates the Material World*, Penguin Putnam, New York, 1995.

Jones, Roger S., *Physics for the Rest of Us*, Contemporary Books, Chicago, 1992.

Lazaris, *Lazaris Interview Book I*, Concept: Synergy Publishing, Beverly Hills, 1988.

Lazaris, *Discovering Your Subconscious*, audio cassette, www.Lazaris.com

O'Murchu, Diarmuid, *Quantum Theology: Spiritual Implications of the New Physics*, Crossroads Publishing, 2004.

Polkinghorne, John, *Quantum Theory: A Very Short Introduction*, Oxford University Press, New York, 2002.

Wolf, Fred Alan, *Taking the Quantum Leap: The New Physics for Non-Scientists*, Harper & Row, New York, 1981.

Zukav, Gary, *The Dancing Wu Li Masters, An Overview of the New Physics*, Perennial Classics, New York, 2001.

MY NOTES

MY NOTES

MY NOTES

MY NOTES